	de la Commande.	de Clichés.			
...Millennieu herbes alethesbes.	C V reprod. Divers	7	7	Jeudi 2 heures	24/1
...marehais	alb ✗	1	2	Mardi	28/12
	alb ✗	1	2	D°	27/12
...rennes.	Almée	3	3	D°	29/1
...Nadar	D° ✗	1	1	D°	29/12
	V. 8° ✗	1	1	D°	29/12
...enr	alb ✗	2	8	Samedi	24/12

6 ⁰⁰

1/24

The World of Proust

as seen by Paul Nadar

The World of Proust

as seen by Paul Nadar

edited by
Anne-Marie Bernard

preface by
Pierre-Jean Rémy
of the Académie Française

photographs by
Paul Nadar

translated by
Susan Wise

The MIT Press
Cambridge, Massachusetts
London, England

COVER PHOTOGRAPH: Marcel Proust, in 1887, at the age of sixteen
Flyleaf excerpts from the Christmas order form (pp. 36-37)

© 2002 Massachusetts Institute of Technology

This work originally appeared in France under the title *Le Monde de Proust vu par Paul Nadar*.
© 1999 Centre des monuments nationaux/Monum, Éditions du Patrimoine, Paris

This book was set in Granjon and was photoengraved, printed and bound in Prodima/Bilbao, Spain.

LIBRARY OF CONGRESS CATALOGING-IN-PUBLICATION DATA

Nadar, Paul, 1856-1939.
 [Monde de Proust vu par Paul Nadar. English]
 The World of Proust, as seen by Paul Nadar / edited by Anne-Marie Bernard; preface
 by Pierre-Jean Rémy; photographs by Paul Nadar; translated by Susan Wise.
 p. cm.
 Includes bibliographical references and index.
 ISBN 0-262-02532-9 (hc: alk. paper)
 1. Proust, Marcel, 1871-1922—Friends and associates—Portraits—Exhibitions.
 2. Portrait photography—France—Exhibitions. 3. Nadar, Paul, 1856-1939—Exhibitions.
 I. Bernard, Anne-Marie. II. Title.
 PQ2631.R63 Z789413 2002
 843'.912—dc21
 [B] 2002022968

Pleasure in this respect is like photography.
What we take, in the presence of the beloved object,
is merely a negative film; we develop it later,
when we are at home, and have once again found
at our disposal that inner dark-room, the entrance to
which is barred to us as long as we are with other people.

Marcel Proust
Within a Budding Grove, Vol. II, p. 239
(Remembrance of Things Past, 1924, Part II)

PREFACE

BY PIERRE-JEAN RÉMY

We have been hearing it for ages: Proust's work is boundless. *Remembrance of Things Past* is at once the record of a highly sensitive, supremely conscious Ego, and the logbook of all the feelings, the passions, the arts, and a few specific social circles at the grand turn of the nineteenth and twentieth centuries. That is why today, in a world that is already so thoroughly charted, we are constantly discovering new territories.

We might think of Proust's oeuvre as a perpetual, ever-revived flow of images experienced over and over in all the tenses of the past and the present, and of the future, too, one that belongs to us, readers of today and tomorrow. The Narrator's story will become a part of our own set of references, whose perspective is and will be magnified every time we reread *Things Past*.

The characters this mighty tide sweeps along are figures whose features and personalities, like the Narrator's, endure the test of time. The "ball of masks" in *Time Regained* is merely the excruciating allegorical representation of that dread fact. We recall the profound dismay of one of our friends whenever he would run across – each time with greater revulsion – Mme. Verdurin

elevated to the rank of Princesse de Guermantes. Could it be true? Oriane now barely on the same social level of the "Mistress," to whom Charlus would say, with a smile that was above contempt, that in matters of "society" and protocol, she simply "could not know"... Even more than the true nature of Saint-Loup's love affairs or of Odette's relationship with Cottard (of which Jean-Yves Tadié gave us *in extremis* a partial key in the appendix to the last volume of the La Pléiade edition), maybe the hardest for us to bear is the metamorphosis of the too-rich parvenue into a Princess, the gossamer creature of our imagination.

Now, Oriane de Guermantes, Mme. Verdurin and Odette de Crécy, every one of the ladies and demimondaines of *Remembrance*, had a model somewhere in the social circles of which Proust was also the chronicler. Whether it be Laure de Chevigné or Lydie Aubernon, the Nadar collections bring them to life for us with a fearsome objectivity.

We dreamed of all those ladies when Proust told us about them, and here they are: we should take a good look at them, we ought to if we want to know "such stuff as dreams are made on." With their low necklines or corseted up to their chins, they all look very naked to us. And if Charles Haas, photographed in 1895, does not disappoint us compared to the rather fond portrait

Proust made of Swann, the Bénardaky mother and daughter, stiff in their period poses, Odette and Gilberte *regained*, appear surprisingly vulnerable.

In the rising tide of memory, the small photographs, fingered one by one like the beads of a secular rosary, are there to remind us that a glance is all that is needed to give birth to a character and to entire pages of books, just like an uneven paving-stone or the stiffness of a starched napkin sets off in the writer the true return of time.

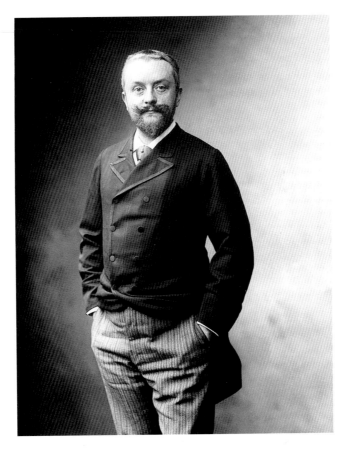

December 26th, 1888♦

Paul Nadar
(1856-1939)

Trained by his father, the great Félix Tournachon, known as Nadar, Paul Nadar took over the latter's studio on the rue d'Anjou in 1886. He is shown here at the time he photographed young Marcel Proust. Gaston Gallimard, in a letter of July 8th, 1922, informed the director of *Vanity Fair* that he was sending the New York magazine a photo of Proust taken by Nadar and kept in his files.[1]

♦ The date (in italics) quoted for each of the photographs of the book, barring a few exceptions, is that of the shot.

WHICH "WORLD OF PROUST"?

BY ANNE BORREL

See if you can find him! Just like in newspaper guessing games, there is someone hidden in this album. Moreover, he is in the margin, out of sight, off camera. Here he is, the sharp-eyed man with a baby face, pointed goatee and naughty moustache: the author, the creator, the deus ex machina. He is "Monsieur Loyal," the ringmaster who brings to life, for a hypothetical audience "in time," a parade of portraits everlastingly "out of time": clear-cut features, peach complexions, laces and fabrics whose colors and cuts we glimpse in the play of light and shadow. Captured in a flash on the emulsion sensitizing the glass plate, they all went to Paul Nadar's studio. And they all, we are told – except the one who brings them to life by freezing them there forever – appear, walk-ons or dancers, in *Remembrance of Things Past*, that colossal "ball of masks."

And yet these smiles, profiles, goatees, "bustles" – so typical of the turn of the century – do not pertain to ghosts or to characters of a novel photographed as they are about to enter the scene. They belong to real people: aristocrats, bourgeois, artists, demimondaines, actresses. The most prominent Parisian "beau monde" and "demi-monde" around the time during which the action of Marcel Proust's novel takes place – 1870-1920 – are assembled here. And since they have

something else in common, they can all pop out of the photographer's box at once: the author of *Remembrance* knew each one of them, frequented them, occasionally admired and even loved them. He collected, compared, collated, cherished, examined their photographs, stored them away in a drawer, year after year, and every once in a while would show them to his intimates; more often he would look at the portraits of the creatures he thus "possessed" by himself, poring over them time and again.

Ascribing this or that of their traits – physical or physiological – this or that of their attitudes or social behaviors, this or that of their "witty remarks" to the fictitious characters of the other "world of Proust," the one of his novel, of "real life" with which the writer equates "literature," is quite another story. Several persons "recognized" themselves, leading to estrangements. Proust had to deny a few too obvious "keys," which explains the famous dedication of *Swann's Way* to Jacques de Lacretelle: "[…] there are no keys for the characters of this book; or else there are eight or ten for a single one […]." His genius could hardly be content with such simplifications. He acknowledged a couple of thoroughly innocent "models" (Marie Bénardaky, Louis de Turenne, Charles Haas…) so as to better disguise unimaginable riddles. When Albert Le Cuziat, the keeper of the specialized "establishment," was asked if he were the model of the disreputable Jupien, he candidly and sensibly replied: "Yes, but there are several of us!"

Indeed, there were "several." The author's sensitive memory – an absolute memory if there ever was one – constantly brought back to him, whether he was aware of it or not, a thousand echos of past perceptions with their original vividness: a glance, a word, a tone of voice, a sound, a fragrance, a taste, the feel of a fabric, the color of a dress, the line of an eyebrow. Progressing from sketch to finished portrait, until they came to life, Proust *composed* his characters: details converged, successive touches were added, borrowed but imagined as well; the character gradually arose from the pen of the writer, who gave it life, his life; it became *real*.

Proust's introductory claim in his dedication of *Swann's Way* to Jacques de Lacretelle was an a posteriori explanation (it is dated April 1918) of one of the characteristic ways in which he worked; actually it was not known until its addressee published it, in 1923, in the "Tribute to Marcel Proust" of the *Nouvelle Revue Française*. It is always quoted when introducing an analysis of the "keys" in *Remembrance of Things Past*. Yet we should complete it by presenting the compositional method Proust provided in *Time Regained*: "Moreover, since individualities (human or otherwise) would in this book be constructed out of numerous impressions which, derived from many girls, many churches, many sonatas, would serve to make a single sonata, a single church and a single girl, should I not be making my book as Françoise

made that *bœuf à la mode* so much savoured by M. de Nor-
pois of which the jelly was enriched by many additional care-
fully selected bits of meat?" The "girls" and the others,
photographed by Paul Nadar, remain eternally "as they
were"... Those who live in Proust's book "achieve form and
solidity" in the world of the reader who, after the author,
creates them with the eyes of the soul.

NADAR AND THE PHOTOGRAPHIC PORTRAIT

BY ANNE-MARIE BERNARD AND AGNÈS BLONDEL

The invention of photography entirely revolutionized the art of the portrait. In 1822, Nicéphore Niepce made the first photograph on glass: a still life that had required an eight-hour pose. It was not until 1839-1840 that the first photographic portraits appeared. Louis Mandé Daguerre was able to reproduce on a metal plate an image, reversed as if in a mirror, in a single exemplar. The daguerreotype developed at an extraordinary pace, but its vogue did not last over ten years. Concurrently, the Englishman William Henry Fox Talbot was able to obtain a paper negative, which he called "calotype," from the Greek *kalos* ("beautiful"), from which he drew positive images. But the grain of the paper was visible and the outlines of the image blurry, whereas the daguerreotype, being more sensitive – you could "count the paving-stones on a street" – continued to prevail. Up until 1860, calotypists kept up their efforts to improve the technique. During that short period, masterpieces of photography on paper were produced: landscapes, monuments and portraits.

The advent of the wet-collodion process on glass, in 1851, would put an end to the quarrel between the advocates of the blurry image (the paper negative) and the upholders of the sharp one (the daguerreotype). Wet collodion allowed photographers to obtain a glass negative, without grain,

thereby challenging the daguerreotype. The operation was delicate: the plate had to be sensitized just before taking the photograph and developed immediately, all in a quarter of an hour! Nonetheless, the process progressed by leaps and bounds. Photographic studios sprang up everywhere.

In 1854, the photographer Disdéri patented a photographic "carte de visite," the size of a calling-card. He made eight negatives on a single plate, thus considerably reducing the cost of the portrait. This invention was a tremendous success and was copied all over the world.

At the same time, Félix Tournachon, known as Nadar, received prominent figures from the worlds of art, literature and science. Allowing his model to move about freely, he did not take his photograph until he caught the characteristic expression. Étienne Carjat, whose portrait of Baudelaire is famous, worked in the same simple fashion. Other photographers preferred more elaborate poses, using accessories and imposing settings, like Disdéri, or trompe-l'œil backgrounds and draperies, like Adolphe Dallemagne (whose collection was taken over by Nadar).

The exceptional portraits of artists and writers by Félix Nadar were taken between 1854 and 1870. If by 1860 he had already begun to develop his clientele, it was especially in the early 1870s that he began taking photographs of "le Tout-Paris" and the world of the stage. At that time, he began training his son Paul, gradually giving him a greater role in the studio, until he handed it over to him entirely in 1886.

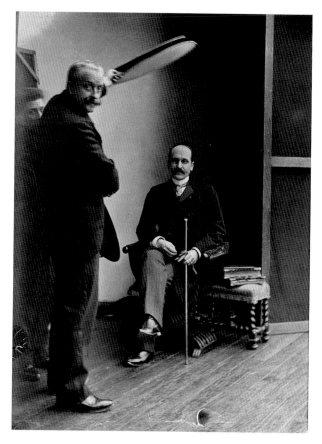

1894, Paul Nadar taking the portrait of M. de Giers, embassy attaché in Rome.

Photographic techniques continued to improve: in 1861 the dry collodion process was developed, allowing the plates to be prepared in advance. Then in 1880, silver-bromide emulsions were produced, so the plates could be commercialized and developed in a laboratory.

Finally, in 1888, George Eastman launched the Kodak, a handy device containing sensitive film. Photography was now accessible to everyone, and professional studios struggled to survive: they had to produce more, at lower prices, and cater to the public's taste. This led to a certain decline in the art of the portrait.

In 1891, there were more than a thousand photography studios in France, and Paris was certainly no less well equipped than the provinces. So it is unavoidable that in focusing on Nadar alone, we have to apologize for those who are missing in this *World of Proust*. The omissions we most regret are Marie Nordlinger, the friend with whom Proust worked on the Ruskin translations; Marie Finaly, his flirtation of the summer of 1892 and the sister of Horace Finaly, Marcel's schoolmate at the Lycée Condorcet; Céleste Albaret, who was in his service during the last eight years of his life; friends of his youth like Jacques Bizet, Daniel Halévy and Fernand Gregh, and the later ones, Anna de Noailles, Jacques-Émile Blanche, Lucien Daudet, Robert de Billy, Gaston Arman de Caillavet, the Bibesco Princes and Bertrand de Salignac-Fénelon.

In 1950, the State purchased from Paul Nadar's widow the entire photographic collection of the studio containing the works by Félix and Paul. That is how some 400,000 glass negatives became the property of the Ministry of Education, which commissioned the photographic archives department to conserve them. Just over one-fifth of the documents have been cataloged and are available, so the collection holds many other treasures in store for us. A considerable number of original prints, manuscripts and letters are conserved at the Bibliothèque Nationale de France. The case of this collection of photographic portraits is nearly unique: owing to the existence of the photographs, a large number of original prints, and order-books, we can appraise practically the Nadars' entire production.

The photographs reproduced here are printed from the full plate, so when they are half-length portraits (Anna de Castellane, Louise de Brantes, Geneviève Mallarmé), we can see the white disk the assistant held at a certain distance from the face; by reflecting the natural light, it improved the lighting. We felt it was worthwhile presenting two portraits of Mme. Proust taken the same day, one not retouched, and therefore more moving, next to the other, more familiar one, which had been retouched. We can also get a better grasp of the decor set up by the photographer, who availed himself of a vast range of scenes: large backdrops, rugs, pieces of furniture and various items. For Paul Nadar, especially for full-

length portraits, the setting was an essential factor, conferring on the photograph the desired mood. If, for the more austere portraits, he preferred a plain backdrop (Barrère, Pozzi, Brissaud) to the ones in a more romanesque vein, he sought a pictorial effect: a plant background (Élaine Greffulhe, Princesse Soutzo) or a large lake with its astonishing rock upon which Princesse Bibesco is half reclining. In the admirable portrait of Fauré, its poetry is entirely created by the misty background. It is also worthwhile mentioning the great care Paul Nadar took with the decor when he photographed Sarah Bernhardt, Julia Bartet and Réjane in their roles.

The close-ups, rather rare, are remarkably modern (Louisa de Mornand as early as 1905, Lucie Delarue-Mardrus in 1914, Léon Daudet and Cocteau in 1930, Coco de Madrazo in 1932). Very frequently, Paul Nadar's negatives (glass plates with silver-bromide gelatine) were retouched, mainly in the face; this explains the rather odd grain of Anatole France's skin, for instance. For the same person, there was often a choice to be made between several photographs, the model having been shot in different poses and at different dates. Furthermore, the technique of enlargement was not yet common practice, and Nadar had to make several trials in different sizes that coincided with the various prints requested.

The purpose of this book is not to offer a representation of the fictional characters of *Remembrance of Things Past* — where the connection with several real persons has only been

hinted at, unless Proust himself had admitted it or it were obvious. The problem of keys to their identity is tricky, and ultimately not essential for the reader of *Remembrance*. Instead, this is more like setting off on a sentimental journey, through Proust's life, in the company of those he knew and loved – rather like those times when he would take out of his commode drawer his beloved photographs to show them to Céleste.

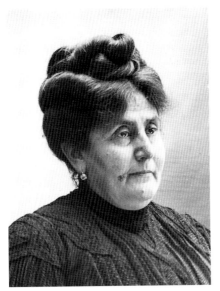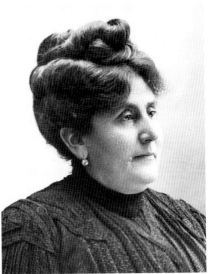

Mme. Proust, *December 5th, 1904.* The comparison between the natural portrait (left) and the retouched one (right) shows that the flaws and shadows that harden and age her face have disappeared.

THE PRINCIPLE OF RETOUCHING

BY ANNE-MARIE BERNARD

The remarkable portraits Félix Nadar had made of his friends, as well as of writers, artists and politicians, soon brought him considerable fame. He brought out what he really sought in each of them: the model's uniqueness and psychological depth. At that time, retouching the negative plate was performed only for technical reasons: to erase a small accidental stain, a gap in the emulsion, a scratch. But this way of working for art and for friends is not very profitable, anyway not enough to support a studio. A large number of photographers decided to set up their own businesses, especially in Paris, and, to be competitive, gave in to the biddings of a more sophisticated clientele: "Photographers had to conform their craft to the taste of a new public, the rich bourgeoisie."[2] Retouching, therefore, would become more widely adopted.

When Paul Nadar took over the studio in 1886, the retouching of negatives had already been practiced for some time, and for reasons of an aesthetic nature: the clientele sought a likable image of itself, glossy, attractive.

This is the type of picture we find in *Remembrance*: "[…] the grandmother […] had wanted, before it was too late, to leave behind the most flattering memory possible of herself."[3]

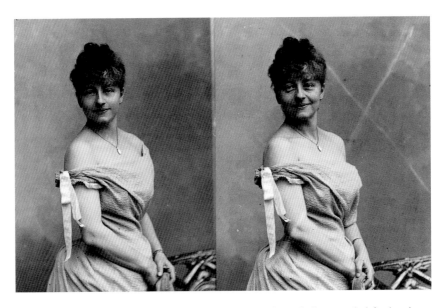

Gyp, in *1891*. Of these two poses taken on a same plate in the space of seconds, the one on the left, selected for the order, is retouched – no wrinkles, no circles or hard shadows; the one on the right, without retouching, was rejected, as we see by the X marked on the back of the plate.

In 1855 a controversy arose between Paul Périer (1812-c.1874), an art connoisseur, vice-president of the Société française de Photographie and a champion of retouching, and Eugène Durieu (1800-1874), president of the same Société, who was set on not amalgamating artistic practices. "So just let me retouch my negatives [...], if I improve them and upgrade them. [...] In short, let us use accurate retouching to achieve something better and more accomplished," Paul Périer insisted.[4]

The Munich photographer Franz Hampfstängl had been the one to invent the process of retouching the negative. At the 1855 World Exhibition in Paris he displayed for the first time a portrait with, and then without, retouching, producing a sensation.[5]

We can easily establish a comparison by placing side by side the portraits of Mme. Proust or of Gyp. Of the two poses, the one that was kept to be printed and given to the client had undergone, more or less depending on the desired result, the usual negative plate treatment: on the glass side, a mat coating that mellows the entire print when it is pulled, and allows one to accentuate the values and enhance them by stressing details; on the emulsion side, corrections carried out very delicately with a retouching pencil to erase flaws.

Retouching removes from the image details deemed unattractive: wrinkles, unsightly circles under the eyes, freckles, or bulkiness of the silhouette, as we can see by the

reduced waistlines for elegant Mme. Greffulhe or imposing Mme. Bénardaky… Gisèle Freund deplores the fact that the "thoughtless, excessive" use of retouching, by suppressing "all the characteristic qualities of a faithful reproduction, […] deprives photography of its essential value."[6] This comment by the Narrator in *Remembrance* : "[…] the "touched-up" photographs which Odette had had taken at Otto's […] did not appeal to Swann so much as a little "cabinet picture" taken at Nice […],"[7] proves that the way we perceive an image depends on our sensibility.

In this book, all the portraits are modern prints faithful to the original plate, just as it came down to us from the Nadar studio.

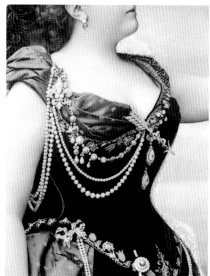

Comtesse Élisabeth Greffulhe, *May 30th, 1895*, and Mme. Nicolas Bénardaky, *June 30th, 1891*.
The coarsely retouched plates show in positive the white marks of the retouching pencil used to slim the waistline.

FAMILY AND INTIMATES

The child who played in the Champs-Élysées and later the youth vacationing on the Normandy beaches claimed his greatest misfortune would be "to be separated from Mamma." Indeed Proust and his mother were very close. To keep her son near her, she accepted his fitfulness, his whims, and later on his night-owl life. Proust was not as utterly taken up with his father, a dominant personality and a leading medical expert, who for a long time was dismayed by his elder son's peculiar behavior, before finally looking upon it with indulgence.

The difference between the Proust parents was apparent in their marked personalities and their social backgrounds. Adrien Proust was a modest provincial who, by dint of hard work, had won a scholarship. Jeanne Weil came from a Jewish bourgeois family, cultured and open-minded, whose income allowed for a certain level of luxury. Proust was raised astride those two worlds, in an intelligent, dedicated family.

Extremely sensitive and high-strung, Proust felt the affection of his family and of his friends as essential to his everyday life. So his intimates appear in this chapter as extensions of the close family circle.

December 5th, 1904
This picture of Mme. Proust shows her actual appearance down to
the slightest detail. Notice in particular her hands, which are swollen
by edema, a symptom of uremia; the framing of the print usually
eliminates them.
In this document you can see the two white cloth reflectors used to diffuse
the light on the subject.

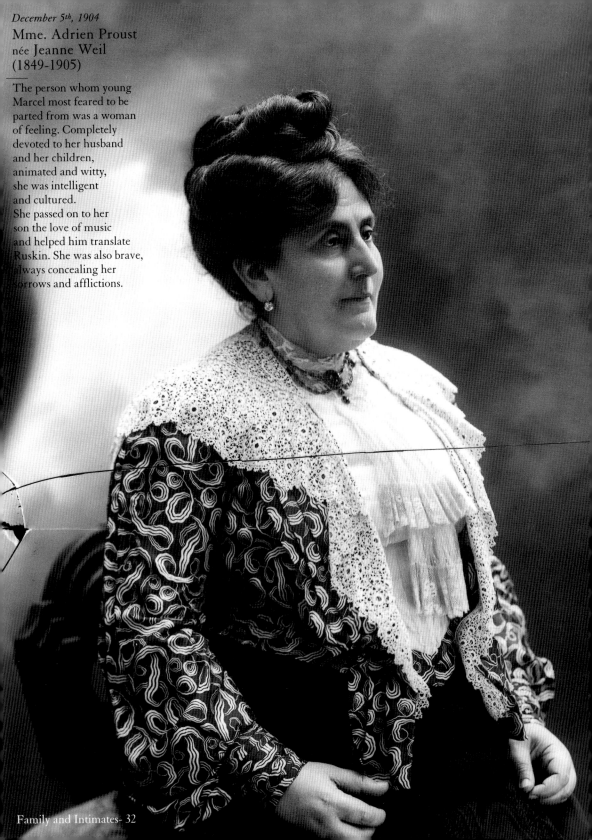

December 5th, 1904

Mme. Adrien Proust
née Jeanne Weil
(1849-1905)

The person whom young
Marcel most feared to be
parted from was a woman
of feeling. Completely
devoted to her husband
and her children,
animated and witty,
she was intelligent
and cultured.
She passed on to her
son the love of music
and helped him translate
Ruskin. She was also brave,
always concealing her
sorrows and afflictions.

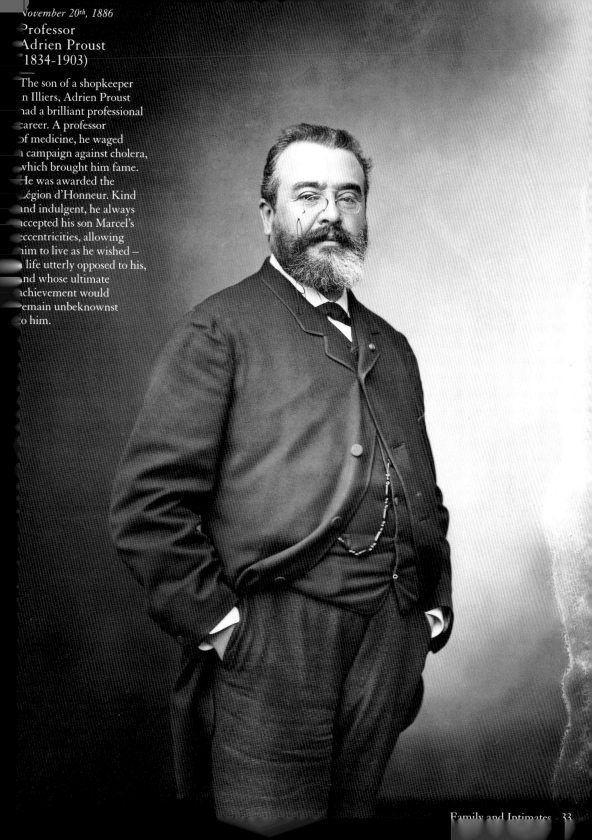

November 20ᵗʰ, 1886

Professor
Adrien Proust
(1834-1903)

The son of a shopkeeper
in Illiers, Adrien Proust
had a brilliant professional
career. A professor
of medicine, he waged
a campaign against cholera,
which brought him fame.
He was awarded the
Légion d'Honneur. Kind
and indulgent, he always
accepted his son Marcel's
eccentricities, allowing
him to live as he wished –
a life utterly opposed to his,
and whose ultimate
achievement would
remain unbeknownst
to him.

Robert Proust
(1873-1935)

Robert Proust, two years younger than Marcel, was a fond, unselfish brother. Despite his passion for mathematics, he complied with his father's wishes and became an eminent surgeon, professor at the Faculty of Medicine and chevalier de la Légion d'Honneur. He inherited Adrien Proust's professional drive, and during the war was a model of fearlessness and bravery. This photograph, compared to Marcel's, reveals the difference in the two brothers' morphologies, matching their entirely opposed personalities. Robert Proust was as fond of sports as his older brother was of the theater and salons.

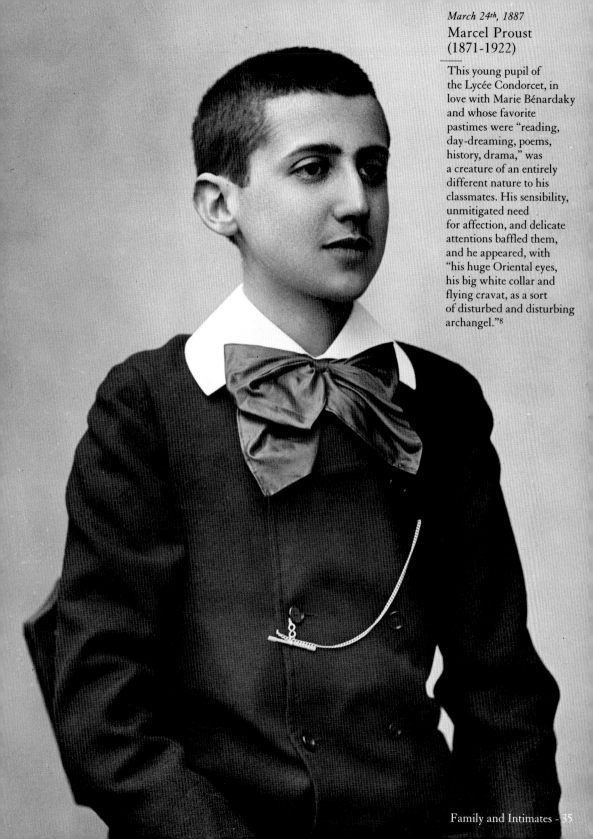

March 24th, 1887

Marcel Proust
(1871-1922)

This young pupil of
the Lycée Condorcet, in
love with Marie Bénardaky
and whose favorite
pastimes were "reading,
day-dreaming, poems,
history, drama," was
a creature of an entirely
different nature to his
classmates. His sensibility,
unmitigated need
for affection, and delicate
attentions baffled them,
and he appeared, with
"his huge Oriental eyes,
his big white collar and
flying cravat, as a sort
of disturbed and disturbing
archangel."[8]

December 21ˢᵗ, 1892
The Christmas commission

On December 21ˢᵗ, 1892, Georges Weil, Mme. Adrien Proust's
brother, commissioned the Nadar studio to execute several
portraits of his parents, the Proust family, himself, his wife and
their baby. The description of the order, consisting of "four sets
of nine portraits and three copper easels under glass," specified
that they were to be delivered to the following addresses:
M. Nathée Weil, 40 bis, faubourg Poissonnière, Mme. Adrien
Proust, 9, boulevard Malesherbes, and Mme. Georges Weil,
24, place Malesherbes. Several of the portraits come directly from
the negatives conserved in the studio; for the others, we had to
reproduce prints from other firms, among which the Braun and
Van Bosch studios. You can see the mark of the thumbtack used
to hold them for the shot at the top of the prints.
This commission gives us the opportunity to observe the face
which Proust had begun to see as that of the Narrator's*
grandmother*: "A few days later I was able to look with pleasure
at the photograph that Saint-Loup had taken of her; […] And yet,
her cheeks having unconsciously assumed an expression of
their own, livid, haggard, like the expression of an animal that
feels that it has been marked down for slaughter, my grandmother
had an air of being under sentence of death, an air involuntarily
sombre, unconsciously tragic, which passed unperceived by me
but prevented Mamma from ever looking at that photograph,
that photograph which seemed to be a photograph not so much of
her mother as of her mother's disease, of an insult that the disease
was offering to the brutally buffeted face of my grandmother."⁹

* The names followed by an asterisk are those of characters in *Remembrance
of Things Past*. The asterisk appears only the first time the name is mentioned.

Jeanne Proust-Weil

Marcel at twenty

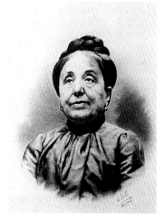

Robert at eighteen

Adrien Proust

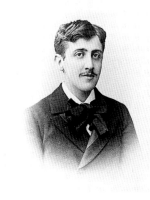

Nathée Weil,
the grandfather (1814-1896)

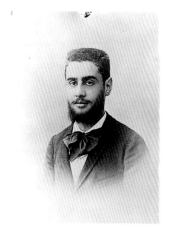

Adèle Berncastel-Weil,
the grandmother (1824-1890)

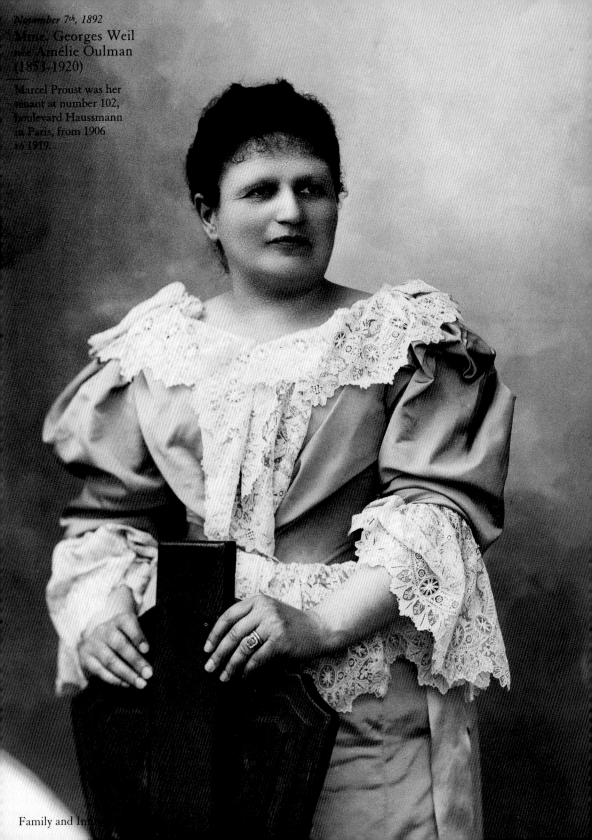

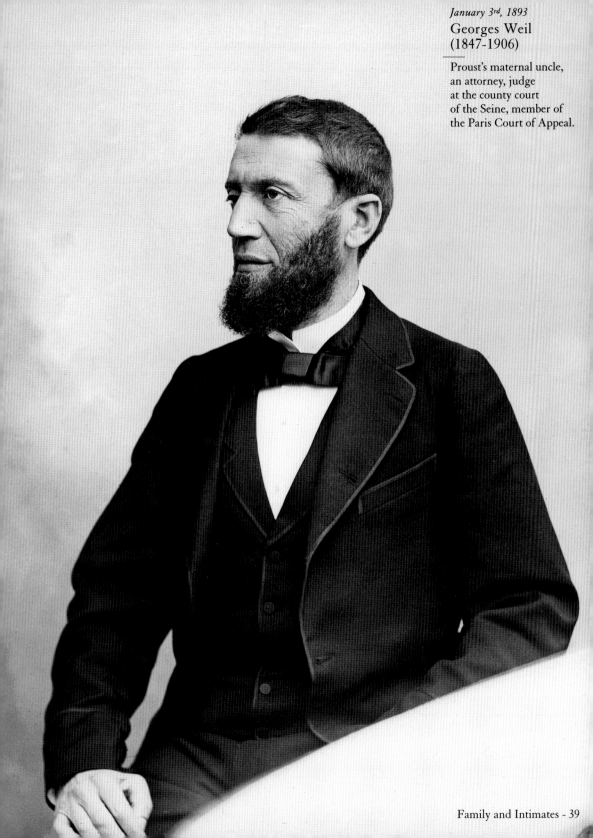

Proust's maternal uncle,
an attorney, judge
at the county court
of the Seine, member of
the Paris Court of Appeal.

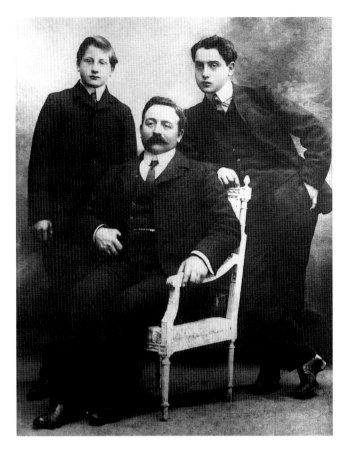

August 8th, 1914
Alfred Agostinelli (1888-1914)
with his father and his brother Émile

Mechanic-chauffeur of the Unic taxi company run by
Jacques Bizet, Alfred Agostinelli (here on the right) drove Proust
through Normandy during the summer of 1907. These excursions
inspired "Impressions of an Automobile Trip," which appeared
in *Le Figaro* on November 19th, 1907. A few years later,
the former chauffeur became Proust's highly intimate secretary.
Having discovered Alfred's passion for airplanes, Proust bought
him one. In December 1913, Agostinelli left Proust, enrolling in a
flying school under the pseudonym "Marcel Swann." On May 30th,
1914, his monoplane crashed and sank in the Mediterranean.
Proust's deep feeling for Agostinelli and the grief he experienced
inspired an important episode in *Albertine Gone*.

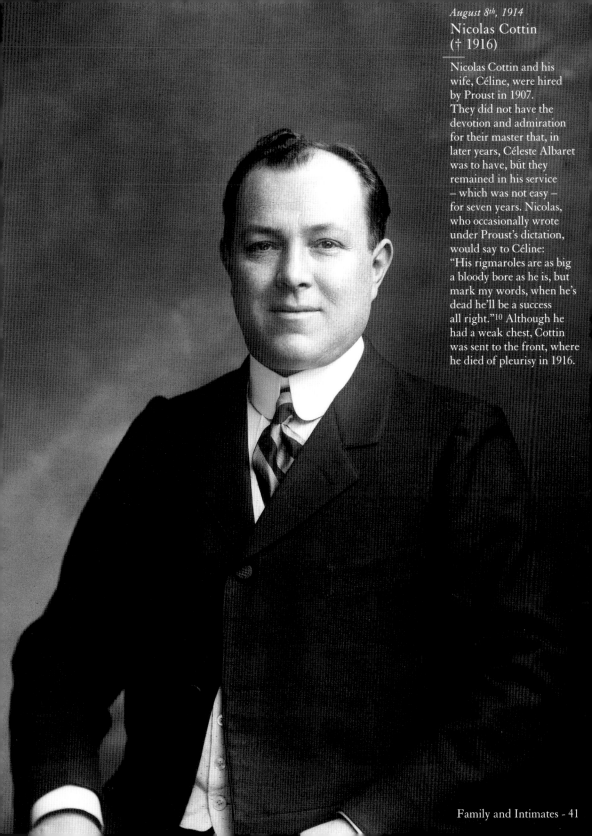

Nicolas Cottin
(† 1916)

Nicolas Cottin and his
wife, Céline, were hired
by Proust in 1907.
They did not have the
devotion and admiration
for their master that, in
later years, Céleste Albaret
was to have, but they
remained in his service
– which was not easy –
for seven years. Nicolas,
who occasionally wrote
under Proust's dictation,
would say to Céline:
"His rigmaroles are as big
a bloody bore as he is, but
mark my words, when he's
dead he'll be a success
all right."[10] Although he
had a weak chest, Cottin
was sent to the front, where
he died of pleurisy in 1916.

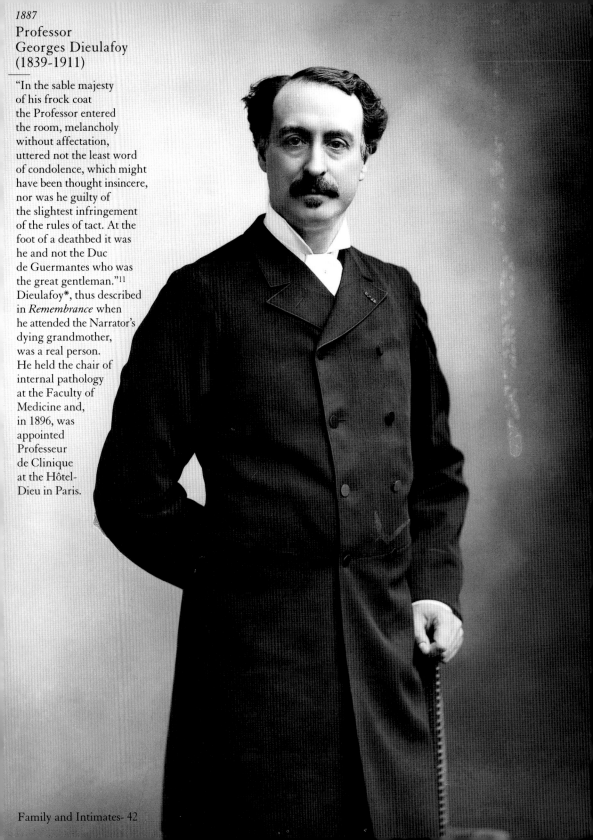

Professor Georges Dieulafoy (1839-1911)

"In the sable majesty of his frock coat the Professor entered the room, melancholy without affectation, uttered not the least word of condolence, which might have been thought insincere, nor was he guilty of the slightest infringement of the rules of tact. At the foot of a deathbed it was he and not the Duc de Guermantes who was the great gentleman."[11] Dieulafoy*, thus described in *Remembrance* when he attended the Narrator's dying grandmother, was a real person. He held the chair of internal pathology at the Faculty of Medicine and, in 1896, was appointed Professeur de Clinique at the Hôtel-Dieu in Paris.

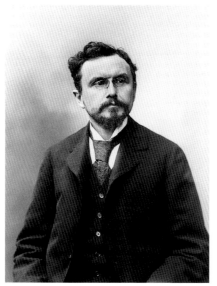

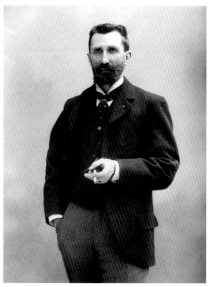

April 28th, 1898
Gabriel Hanotaux
(1853-1944)

Gabriel Hanotaux, a friend of Adrien
Proust, was Foreign Minister from
1894 to 1898 and then special emissary
to Rome in 1920. He also wrote a number
of historical studies. Thanks to his
recommendation, Marcel was appointed
librarian at the Mazarine library in June
1895, and would be granted the long
leaves of absence he would request later on.
Proust borrowed his diplomatic language
for the character of M. de Norpois*.

Januar 1898
Camille Barrère
(1851-1940)

A diplomat, Camille Barrère was a friend
of Dr. Adrien Proust, whom he backed
in his campaign against cholera when
England's accord was required to impose
the quarantine line at Suez.
He was French ambassador to Italy
from 1897 to 1924.

Reynaldo Hahn
(1875-1947)

The deep friendship that
bound Proust to Reynaldo
Hahn for twenty-eight years
began with a liaison in 1894
and was kept up through
a close correspondence.
This young, highly gifted
musician, the creator
of *Ciboulette*, sang his
melodies at Madeleine
Lemaire's. Sensitive and
refined, he was a dazzling
conversationalist. Proust
visited Brittany with him
in 1895, and immediately
started writing his first
novel, *Jean Santeuil*: "I want
you to be present all
the time but like a god
in disguise, unrecognized
by mortals," he wrote him
in March 1896.[12]
In 1900 they traveled
to Venice together, in
the company of Marie
Nordlinger, a young
relative of the Hahn family
who had come to Paris to
study painting and sculpture.
Proust kept him up on his
work, and did a first
reading of *Swann's Way* to
an enthusiastic Reynaldo.

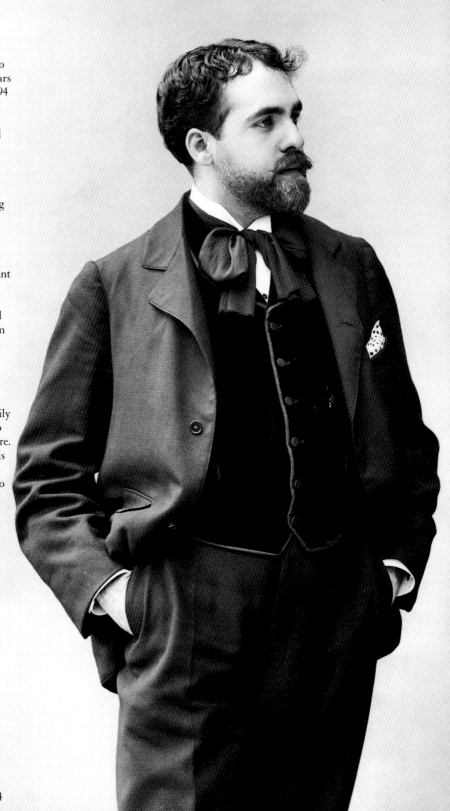

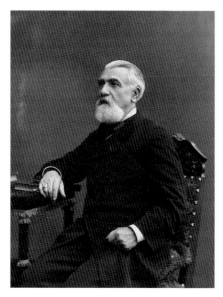

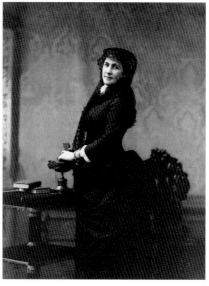

March 18th, 1881
Carlos or Karl Salomon Hahn
(† 1897)

December 1880
Mme. Carlos Hahn
née Elena Maria Echenagucia
(† 1912)

After making a fortune in Caracas, where he married a rich heiress of a Basque family settled in Venezuela, Carlos Hahn moved permanently to Paris in 1878. Proust was very close to the Hahn children, Reynaldo and his sisters, during the sickness and death of their parents. In July 1897, although suffering from an acute attack of asthma, he went out to the family's home in Saint-Cloud for news of Mr. Hahn. Then, fifteen years later, he observed the progression of Elena Maria's sickness with the same affectionate, grieving solicitude. "She was a woman with a generous heart and who had been a great beauty," he confided to Georges de Lauris in 1912.[13] That same year 1912, in an earlier letter dated January 3rd, he assured Mme. Hahn of his "veneration," his "tender, filial respect," thanking her for having shown him "a mother's kindness."[14]

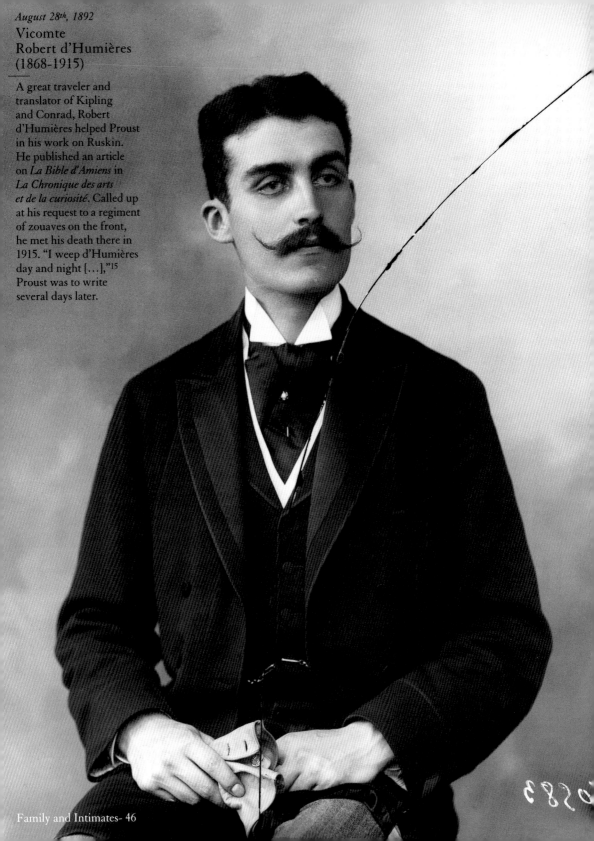

August 28th, 1892

Vicomte
Robert d'Humières
(1868-1915)

A great traveler and
translator of Kipling
and Conrad, Robert
d'Humières helped Proust
in his work on Ruskin.
He published an article
on *La Bible d'Amiens* in
*La Chronique des arts
et de la curiosité.* Called up
at his request to a regiment
of zouaves on the front,
he met his death there in
1915. "I weep d'Humières
day and night […],"[15]
Proust was to write
several days later.

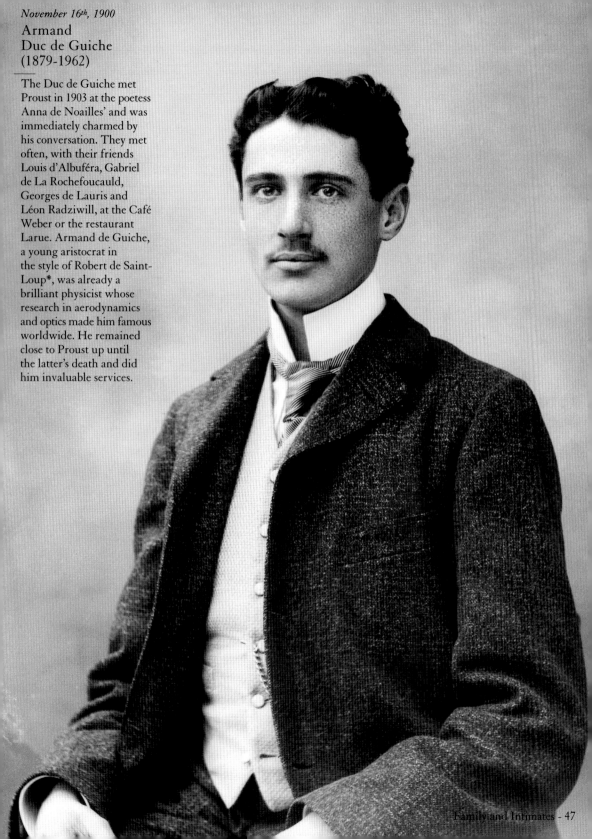

Armand
Duc de Guiche
(1879-1962)

The Duc de Guiche met
Proust in 1903 at the poetess
Anna de Noailles' and was
immediately charmed by
his conversation. They met
often, with their friends
Louis d'Albuféra, Gabriel
de La Rochefoucauld,
Georges de Lauris and
Léon Radziwill, at the Café
Weber or the restaurant
Larue. Armand de Guiche,
a young aristocrat in
the style of Robert de Saint-
Loup*, was already a
brilliant physicist whose
research in aerodynamics
and optics made him famous
worldwide. He remained
close to Proust up until
the latter's death and did
him invaluable services.

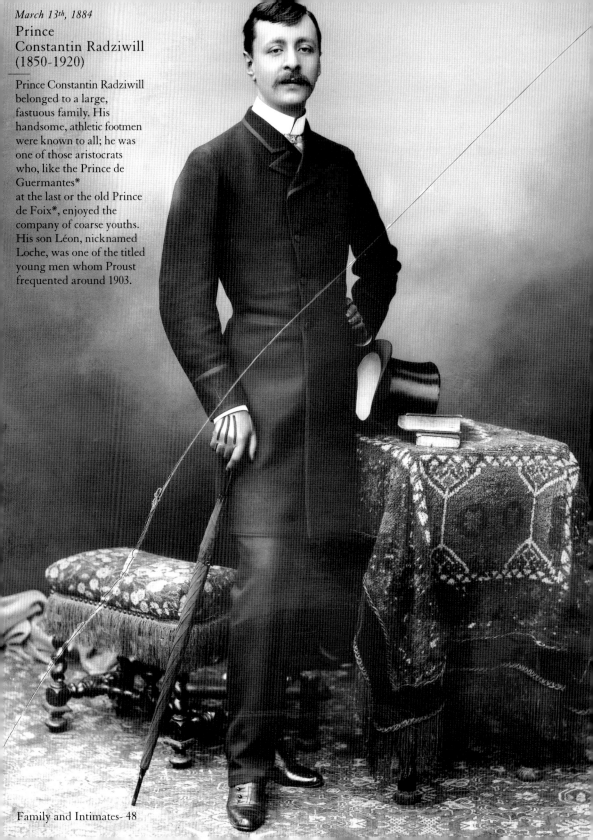

March 13th, 1884

Prince
Constantin Radziwill
(1850-1920)

Prince Constantin Radziwill
belonged to a large,
fastuous family. His
handsome, athletic footmen
were known to all; he was
one of those aristocrats
who, like the Prince de
Guermantes*
at the last or the old Prince
de Foix*, enjoyed the
company of coarse youths.
His son Léon, nicknamed
Loche, was one of the titled
young men whom Proust
frequented around 1903.

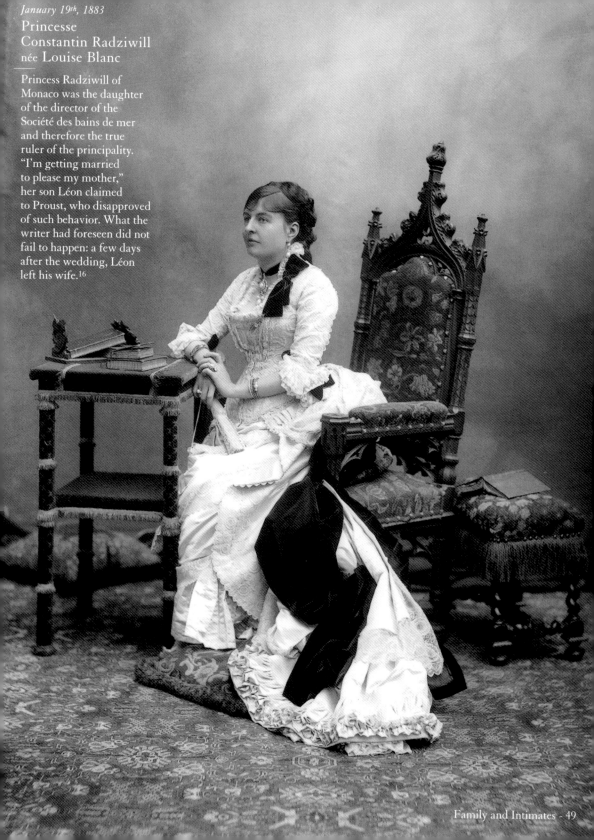

Princesse
Constantin Radziwill
née Louise Blanc

Princess Radziwill of
Monaco was the daughter
of the director of the
Société des bains de mer
and therefore the true
ruler of the principality.
"I'm getting married
to please my mother,"
her son Léon claimed
to Proust, who disapproved
of such behavior. What the
writer had foreseen did not
fail to happen: a few days
after the wedding, Léon
left his wife.[16]

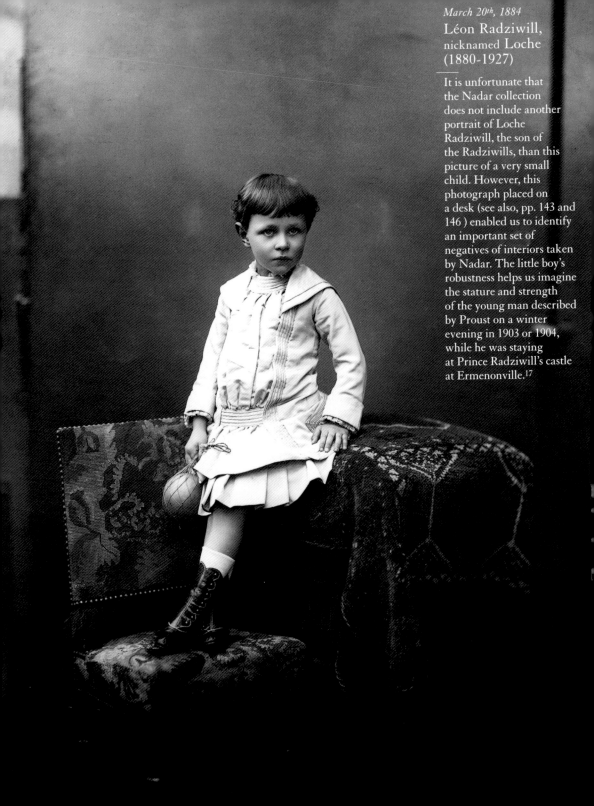

It is unfortunate that the Nadar collection does not include another portrait of Loche Radziwill, the son of the Radziwills, than this picture of a very small child. However, this photograph placed on a desk (see also, pp. 143 and 146) enabled us to identify an important set of negatives of interiors taken by Nadar. The little boy's robustness helps us imagine the stature and strength of the young man described by Proust on a winter evening in 1903 or 1904, while he was staying at Prince Radziwill's castle at Ermenonville.[17]

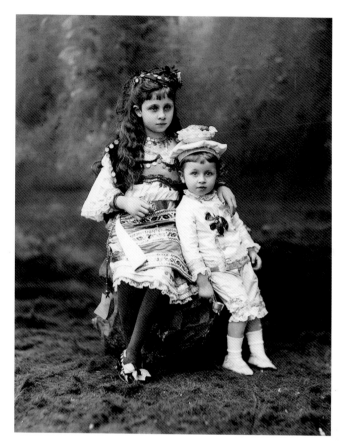

May 24th, 1881

Jeanne Pouquet and her brother Pierre

How could this little girl, dressed up as a fortune-teller, imagine
that ten years later she would inspire so much feeling in Marcel
Proust, a friend of her fiancé Gaston Arman de Caillavet? Proust
courted her assiduously, yet she remained indifferent. Like
the Narrator in love with Gilberte Swann*, he sought by every
means to get hold of a photograph of her: "To acquire one
of these, I stooped – with friends of the Swanns, and even with
photographers – to servilities which did not procure for me what
I wanted, but tied me for life to a number of extremely tiresome
people."[18] She married Gaston Arman de Caillavet in 1903
and Proust soon stopped loving her. Their little daughter,
Simone – just as for the Narrator, the daughter of Gilberte
and Saint-Loup, who, "made out of all the years [he] had lost [...],
symbolised [his] youth" – meant a great deal to him.[19]

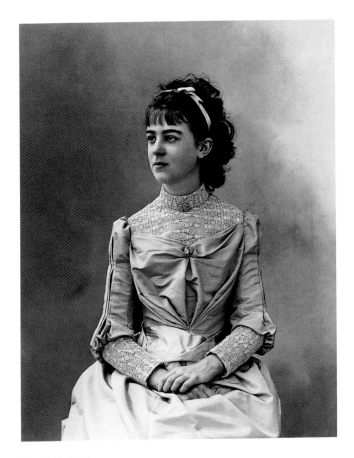

June 12th, 1889

Élisabeth de Gramont
(1875-1954)

The daughter of the Duc Agénor de Gramont and half-sister
of the Duc de Guiche, Élisabeth de Gramont, future Duchesse
de Clermont-Tonnerre, is still very young in this photograph.
Proust met her around 1904, and she entertained him at Glisolles
in October 1907. He left his hosts toward midnight, his legs
wobbly with caffeine, "so charitably guided on the nocturnal
steps" by the Duc de Clermont-Tonnerre.[20] The intelligent
and "progressive-minded" Duchesse knew and entertained most
of the celebrities of her day: Colette, Barrès, France, Valéry,
Degas, Rodin… A memorialist, she portrayed her times with
a clear eye and an indulgent irony. She said of Proust's work:
"It is not the kind of story where we are in a rush to know how it
ends, but a charmed wandering from the earth to heaven and
down to the bottom of the oceans."

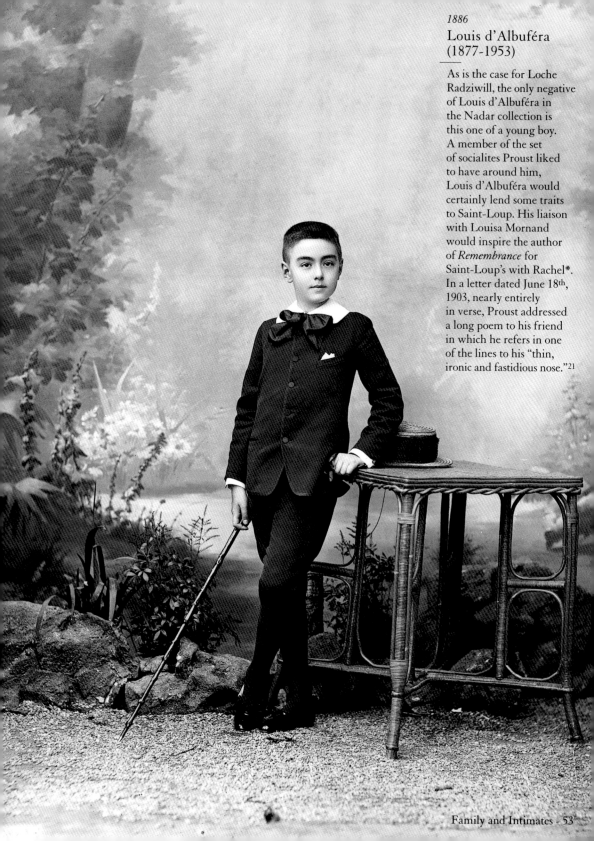

Louis d'Albuféra
(1877-1953)

As is the case for Loche
Radziwill, the only negative
of Louis d'Albuféra in
the Nadar collection is
this one of a young boy.
A member of the set
of socialites Proust liked
to have around him,
Louis d'Albuféra would
certainly lend some traits
to Saint-Loup. His liaison
with Louisa Mornand
would inspire the author
of *Remembrance* for
Saint-Loup's with Rachel*.
In a letter dated June 18th,
1903, nearly entirely
in verse, Proust addressed
a long poem to his friend
in which he refers in one
of the lines to his "thin,
ironic and fastidious nose."21

Proust sought on a number of occasions to procure photographic portraits of the men and the women whom he loved or admired, which he kept with his most treasured mementos. He would often have Céleste, his housekeeper, bring them to him and would pore over them intently.

Among the society figures, Charles Haas – who blended culture, intelligence and an exquisite manner – was the epitome of elegance. Swann*, as well, was a member of Right Bank society and a dandy. He transgressed the rigid partitions of society by frequenting several very closed circles, thus highlighting a certain inconsequence of the salons. "In short, if I reflected, the matter of my experience came to me from Swann, [...] it was he who, ever since the Combray days, had given me the desire to go to Balbec, where, but for him, [...] I should never have known Albertine. [...] But without Swann I should not even have known the Guermantes, [...] I should not have made the acquaintance of Saint-Loup and of M. de Charlus which in turn caused me to know the Duchesse de Guermantes and, through her, her cousin, so that my very presence at this moment at the Prince de Guermantes' from which suddenly sprang the idea of my work [...] also came to me from Swann."[22]

Proust explored different worlds, attended the Princesse Mathilde's Bonapartist salon, met the Comte Robert de Montesquiou, a poet and man of taste, then the Comtesse Greffulhe, the queen of the faubourg Saint-Germain.

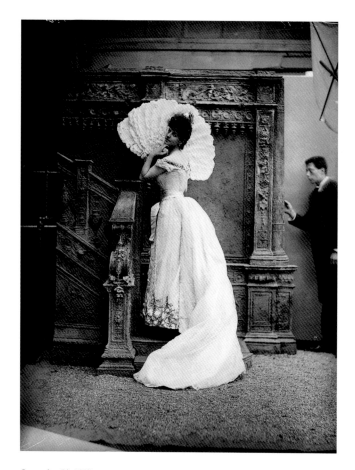

September 5ᵗʰ, 1887
Mme. Greffulhe, the principal model for the Princesse and the Duchesse
de Guermantes*, in an evening dress signed by the famous couturier Worth,
in front of Nadar's assistant.
The decor of the Nadar studio allowed the train of the dress to fan out on the steps.
"Her neck and shoulders emerged from a drift of snow-white muslin, against which
fluttered a swansdown fan, but below this her gown, the bodice of which had for its
sole ornament innumerable spangles (either little sticks and beads of metal, or possibly
brilliants), moulded her figure with a precision that was positively British."²³

"Mme. Verdurin was sitting upon a high Swedish chair of waxed pinewood, which a violinist from that country had given her, and which she kept in her drawing-room, although in appearance it suggested a school 'form,' and 'swore,' as the saying is, at the really good antique furniture which she had besides; but she made a point on keeping on view the presents which her 'faithful' were in the habit of making her from time to time, so that the donors might have the pleasure of seeing them there when they came to the house. [...]
"From this lofty perch she would take her spirited part in the conversation of the 'faithful,' and would revel in all their fun; [...] At the least witticism aimed by any of the circle against a 'bore,' or against a former member of the circle who was now relegated to the limbo of 'bores' [...] she would utter a shrill cry, shut tightly her little bird-like eyes which were beginning to be clouded over by a cataract [...]. So, stupefied with the gaiety of the 'faithful,' drunken with comradeship, scandal and asseveration, Mme. Verdurin, perched on her high seat like a cage-bird whose biscuit has been steeped in mulled wine, would sit aloft and sob with fellow-feeling."[24]

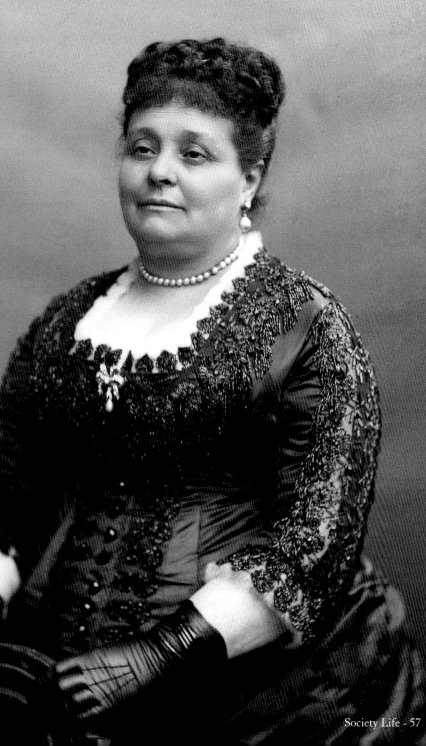

January 13th, 1883

Mme. Georges Aubernon
née Lydie Lemercier de Nerville (1825-1899)

Even if the faubourg Saint-Germain never showed up at Mme. Aubernon's – the principal model of Mme. Verdurin* – her literary and artistic salon was still very prominent. Plump and vivacious, she looked, in Montesquiou's words, "like Queen Pomaré on the lavatory seat." She entertained on Wednesdays: the topic of conversation was announced in advance and when interest began to lag, the hostess "would ring her famous little bell to secure attention for the speaker of the moment."[25] It was in her salon that Proust, admitted around 1892, met Robert de Montesquiou. He often went with the portraitist Jacques-Émile Blanche and, later, with Reynaldo Hahn.

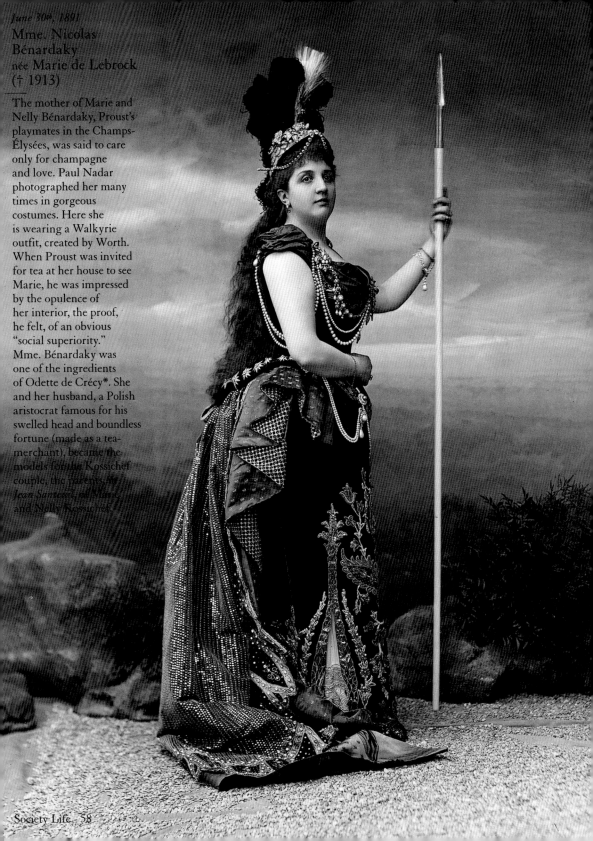

June 30th, 1891

Mme. Nicolas Bénardaky
née Marie de Lebrock
(† 1913)

The mother of Marie and
Nelly Bénardaky, Proust's
playmates in the Champs-
Élysées, was said to care
only for champagne
and love. Paul Nadar
photographed her many
times in gorgeous
costumes. Here she
is wearing a Walkyrie
outfit, created by Worth.
When Proust was invited
for tea at her house to see
Marie, he was impressed
by the opulence of
her interior, the proof,
he felt, of an obvious
"social superiority."
Mme. Bénardaky was
one of the ingredients
of Odette de Crécy*. She
and her husband, a Polish
aristocrat famous for his
swelled head and boundless
fortune (made as a tea-
merchant), became the
models for the Kossichef
couple, the parents of
Jean Santeuil of Marie
and Nelly Kossichef.

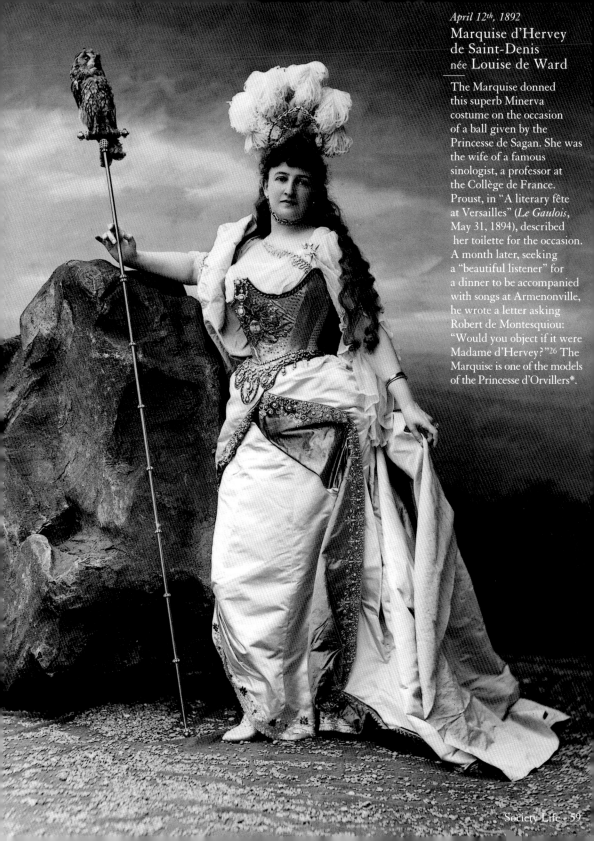

Marquise d'Hervey de Saint-Denis née Louise de Ward

The Marquise donned this superb Minerva costume on the occasion of a ball given by the Princesse de Sagan. She was the wife of a famous sinologist, a professor at the Collège de France. Proust, in "A literary fête at Versailles" (*Le Gaulois*, May 31, 1894), described her toilette for the occasion. A month later, seeking a "beautiful listener" for a dinner to be accompanied with songs at Armenonville, he wrote a letter asking Robert de Montesquiou: "Would you object if it were Madame d'Hervey?"[26] The Marquise is one of the models of the Princesse d'Orvillers*.

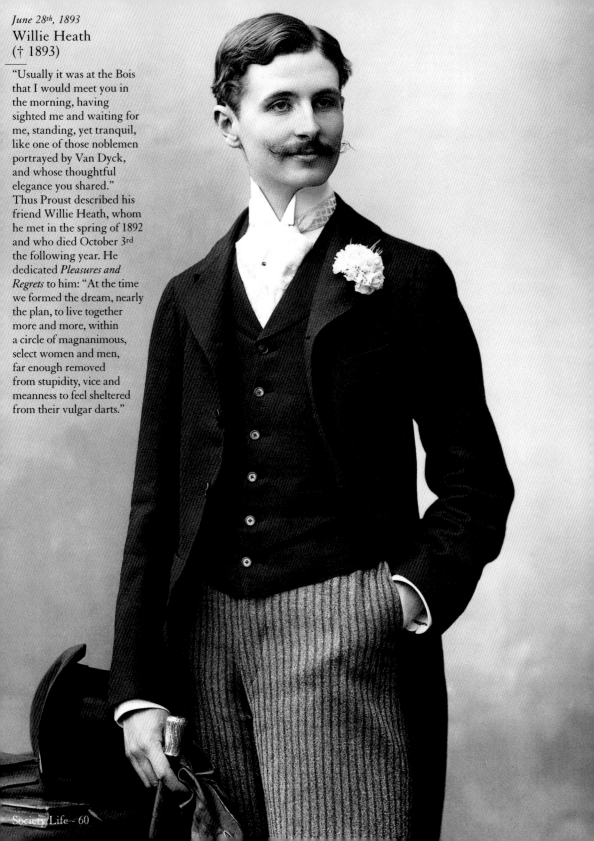

June 28th, 1893

Willie Heath
(† 1893)

"Usually it was at the Bois that I would meet you in the morning, having sighted me and waiting for me, standing, yet tranquil, like one of those noblemen portrayed by Van Dyck, and whose thoughtful elegance you shared." Thus Proust described his friend Willie Heath, whom he met in the spring of 1892 and who died October 3rd the following year. He dedicated *Pleasures and Regrets* to him: "At the time we formed the dream, nearly the plan, to live together more and more, within a circle of magnanimous, select women and men, far enough removed from stupidity, vice and meanness to feel sheltered from their vulgar darts."

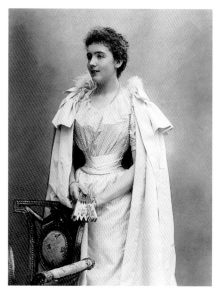

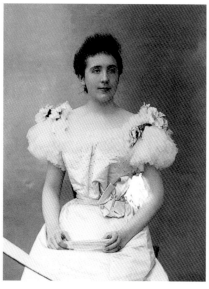

November 30th, 1893
Marie Bénardaky
(1874- ?)

July 16th, 1895
Nelly Bénardaky

"[…] for Gilberte's arrival in the Champs-Élysées in the snow, I remembered someone who had been the great love of my life without her ever knowing it (or the other great love of my life since there were at least two), Mademoiselle Bénardaky." It was in those words that Proust spoke of Marie Bénardaky on April 20th, 1918, in his dedication to Jacques de Lacretelle of the first volume of *Remembrance*. This photograph shows her six years after the winter of 1886-1887, the time she occupied all his daydreams. When, as an adolescent, Proust would meet up in the Parc Monceau or in the Champs-Élysées with the two sisters already engaged in a game of prisoner's base, he would always arrange to be on Marie's side: "[…] once when he hesitated out of politeness, and made as if to join her sister, the good-natured Nelly […] said: "No, you're on Marie's side, it makes you so happy."[27]

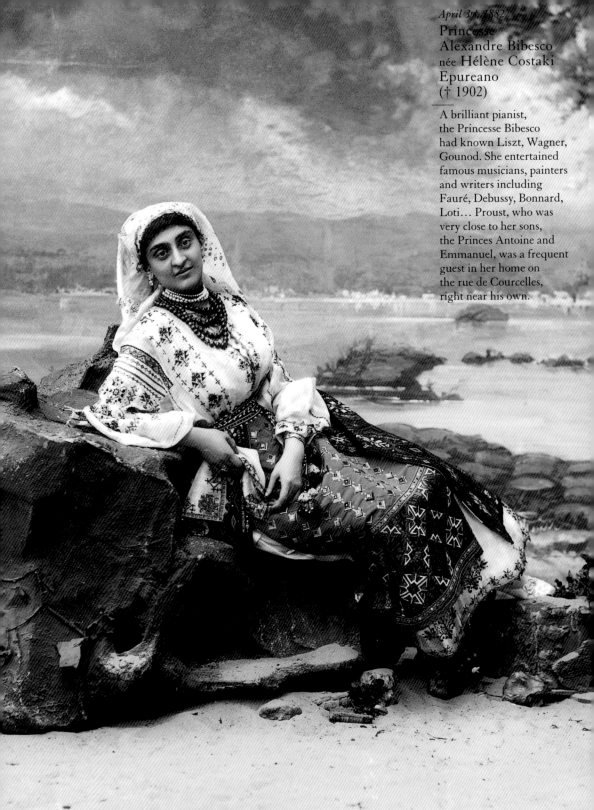

Princesse
Alexandre Bibesco
née Hélène Costaki
Epureano
(† 1902)

A brilliant pianist,
the Princesse Bibesco
had known Liszt, Wagner,
Gounod. She entertained
famous musicians, painters
and writers including
Fauré, Debussy, Bonnard,
Loti… Proust, who was
very close to her sons,
the Princes Antoine and
Emmanuel, was a frequent
guest in her home on
the rue de Courcelles,
right near his own.

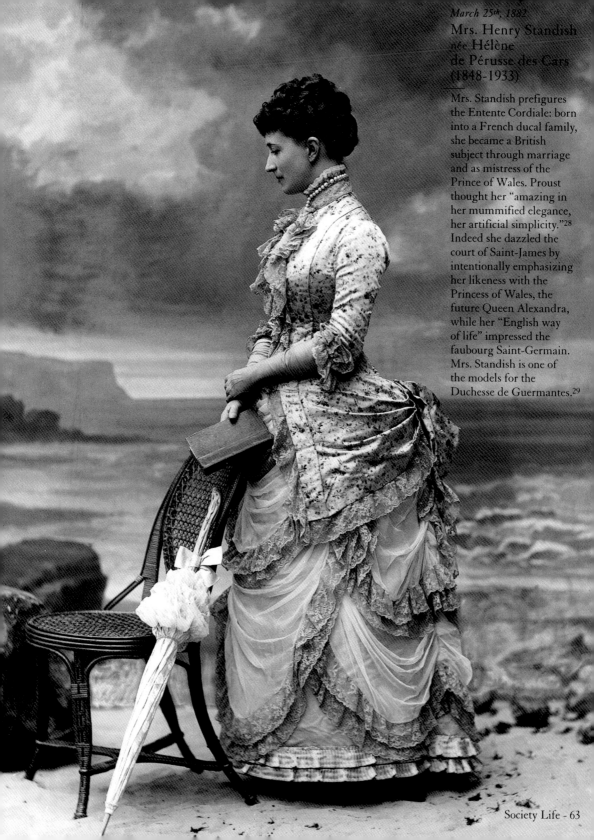

Mrs. Henry Standish
née Hélène
de Pérusse des Cars
(1848-1933)

Mrs. Standish prefigures
the Entente Cordiale: born
into a French ducal family,
she became a British
subject through marriage
and as mistress of the
Prince of Wales. Proust
thought her "amazing in
her mummified elegance,
her artificial simplicity."[28]
Indeed she dazzled the
court of Saint-James by
intentionally emphasizing
her likeness with the
Princess of Wales, the
future Queen Alexandra,
while her "English way
of life" impressed the
faubourg Saint-Germain.
Mrs. Standish is one of
the models for the
Duchesse de Guermantes.[29]

Prince and Princesse Joseph de Caraman-Chimay (1858-1937) and (1874- ?)

The union, in 1890, of the Prince de Caraman-Chimay, Comtesse Greffulhe's older brother, and Clara Ward, an heiress from Michigan, was typical of the matrimonial policy practiced by European aristocrats, boosting the family fortunes with the New World's prospects. Young, rich and handsome, these heroes of a modern fairy-tale divorced after the Princess ran off with a gypsy musician, Janczi Rigo. The Baron de Charlus* refers to this social drama when speaking about some property that had changed hands: "[…] I wish to know nothing more of this house that has let itself be dishonoured, any more than of my cousin Clara de Chimay after she left her husband."[30]

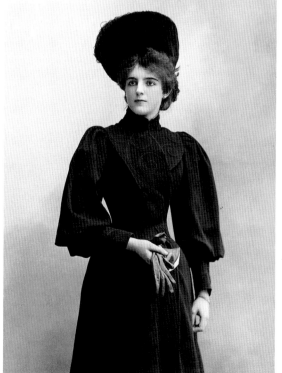

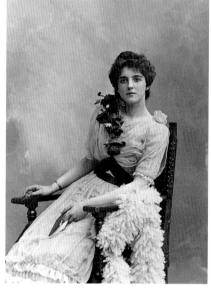

1898

Clara's beauty, so apparent in her portraits, is set off by these three outfits by the couturier Worth. The Princess was a frequent client of the Nadar studio – she also had her daughter Marie photographed (here, top left, *August 4th, 1894*, at the age of three). Geneviève Mallarmé, who was visiting the Nadars, was able to describe her (in a letter to her father, dated May 9th, 1897) posing "wearing just a pink silk chemise […] a beautiful head and neck; but what a tummy and what a derrière […]."[31]

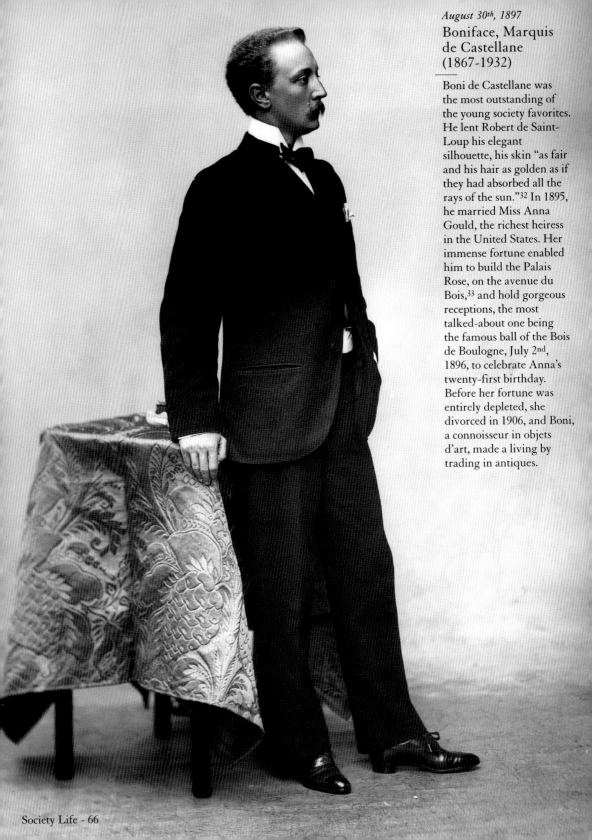

Boniface, Marquis de Castellane (1867-1932)

Boni de Castellane was the most outstanding of the young society favorites. He lent Robert de Saint-Loup his elegant silhouette, his skin "as fair and his hair as golden as if they had absorbed all the rays of the sun."[32] In 1895, he married Miss Anna Gould, the richest heiress in the United States. Her immense fortune enabled him to build the Palais Rose, on the avenue du Bois,[33] and hold gorgeous receptions, the most talked-about one being the famous ball of the Bois de Boulogne, July 2nd, 1896, to celebrate Anna's twenty-first birthday. Before her fortune was entirely depleted, she divorced in 1906, and Boni, a connoisseur in objets d'art, made a living by trading in antiques.

July 24th, 1901
Marquise de Castellane
née Anna Gould
(1875-1966)

Boni de Castellane's rich wife was, as Boni himself – who openly
cheated on her – said, "the other side of the coin." An energetic
woman, whose huge eyes were not enough to make her attractive,
she did not discover marital bliss until 1908 with her second
husband, cousin of the first, Hélie, the Prince de Sagan. Unaware
of their estrangement and their family ties, someone wanted to
introduce Sagan to Castellane, an opportunity for Boni to reply
with one of those vindicative quips reported in gossip columns:
"It's not necessary, we both served in the same body."[34]

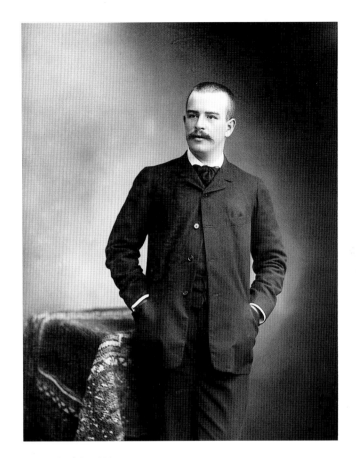

September 7th, 1886

Henri, Marquis de Breteuil
(1848-1916)

Henri de Breteuil, a habitué of the salon of the Duchesse de La Trémoïlle, also assiduously frequented that of Mme. de Chevigné, along with the Marquis de Lau and the Comtes de Gontaut-Biron and Costa de Beauregard. An officer during the last years of the Second Empire, he became friends with the Prince of Wales, the future Edward VII, and the Marquis de Galliffet, the future general.

He left the army after 1870 and went into politics. A Monarchist deputy of the Hautes-Pyrénées, he was a respected orator at the Chamber. In 1907, he championed the Entente Cordiale, and he was the one to arrange for Edward VII to visit the collection of the famous art lover Camille Groult. With the Comte de Turenne, Henri inspired Proust for the character of the marquis de Bréauté* – "who mixed with no one below the rank of Highness. But he laughed at them in his heart and longed only to spend his days in museums."[35] At the time he knew Proust and hosted him, he was fifty-four and at the height of his social career.

Comtesse
Adhéaume
de Chevigné
née Laure de Sade
(1860-1936)

Proust had caught glimpses
of the Comtesse de Chevigné
in 1891 at Mme. Straus' and
Mme. Lemaire's; he was
drawn to her birdlike
profile, her blue eyes and
her golden hair, which
she wore up. "I had heart
attacks every time I met
you," he was to confess later
on, recalling that spring of
1892 when he would watch
for her during her morning
strolls. Their friendship
lasted twenty-eight years,
until Mme. de Chevigné
was hurt by her portrait
as Mme. de Guermantes
in the second volume of
Remembrance. Proust was
very affected by it and
lamented to Jean Cocteau:
"When I was twenty,
she refused to love me;
will she refuse to read me
now I am forty and have
made from her all that
is best in the Duchesse
de Guermantes?"[36]

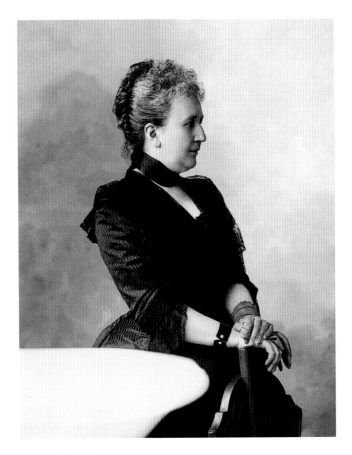

August 5th, 1892

Marquise Sauvage de Brantes
née Louise Lacuée de Cessac
(1842-1914)

The Marquise de Brantes, Robert de Montesquiou's aunt, was
a charming, clever hostess, to whose home Proust took Reynaldo
Hahn when they first became friends. The writer, who liked
to praise her "medal profile refined by French grace" and "lofty
intelligence,"[37] was very fond of her and often invited her to
his dinner parties, at home or at the Ritz.

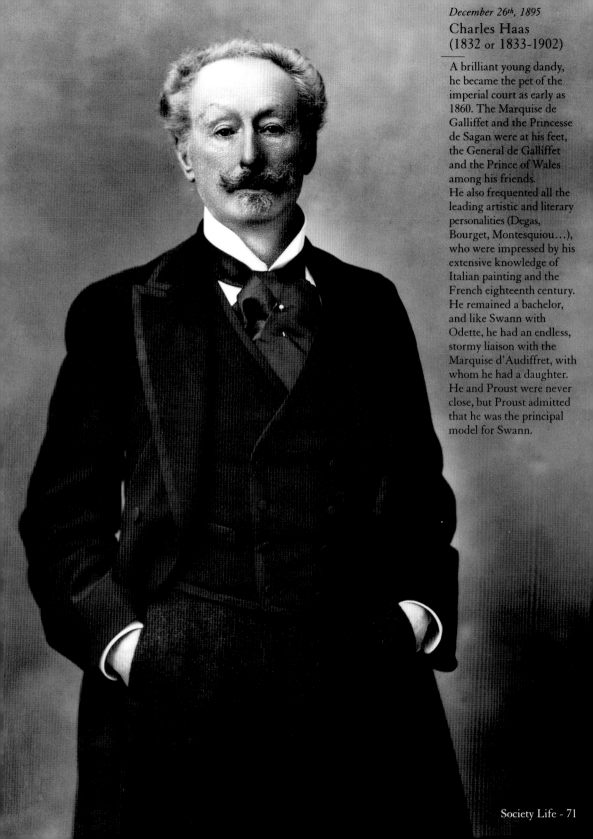

Charles Haas
(1832 or 1833-1902)

A brilliant young dandy,
he became the pet of the
imperial court as early as
1860. The Marquise de
Galliffet and the Princesse
de Sagan were at his feet,
the General de Galliffet
and the Prince of Wales
among his friends.
He also frequented all the
leading artistic and literary
personalities (Degas,
Bourget, Montesquiou…),
who were impressed by his
extensive knowledge of
Italian painting and the
French eighteenth century.
He remained a bachelor,
and like Swann with
Odette, he had an endless,
stormy liaison with the
Marquise d'Audiffret, with
whom he had a daughter.
He and Proust were never
close, but Proust admitted
that he was the principal
model for Swann.

Comtesse Henry Greffulhe
née Élisabeth de Caraman-Chimay (1860-1952)

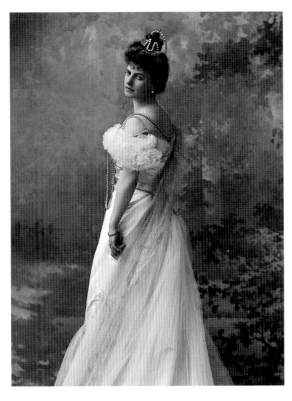

August 7th, 1900

"There was not a single bit of her you might see in someone else nor even *anywhere else*. But the whole mystery of her beauty lies in the glow, and above all the enigma of her eyes. I have never seen such a beautiful woman," Proust wrote in 1893, still entirely captivated, several hours after seeing the Comtesse among the Princesse de Wagram's guests.[38]

In 1894, at Robert de Montesquiou's, Proust was finally introduced to the Comtesse Greffulhe: "I can't tell how many times I went to the Opéra, just to admire her bearing as she went up the stairway."[39] Her air and romantic elegance point to the Duchesse de Guermantes, while her prominent social position relates her to the Princesse de Guermantes. She had the greatest regard for her beauty, which inspired her to write: "I don't believe there is in the world a pleasure comparable to that of a woman who is aware she is the center of everyone's attention, imparting to her delight and energy."[40] Their stereoscope was "the pride and joy"[41] of the Comte and the Comtesse Greffulhe, and when the Comtesse wished to take lessons in photography, she naturally turned to Paul Nadar.[42] Here, Élisabeth Greffulhe is wearing a black velvet evening gown by Worth adorned with large white lily motifs. The Comtesse and her cousin Robert de Montesquiou shared their admiration for one another, just like the Duchesse de Guermantes and the Baron de Charlus. The last verse of a sonnet she had inspired him to write, "lovely lily gazing with your black pistils,"[43] especially gratified her.

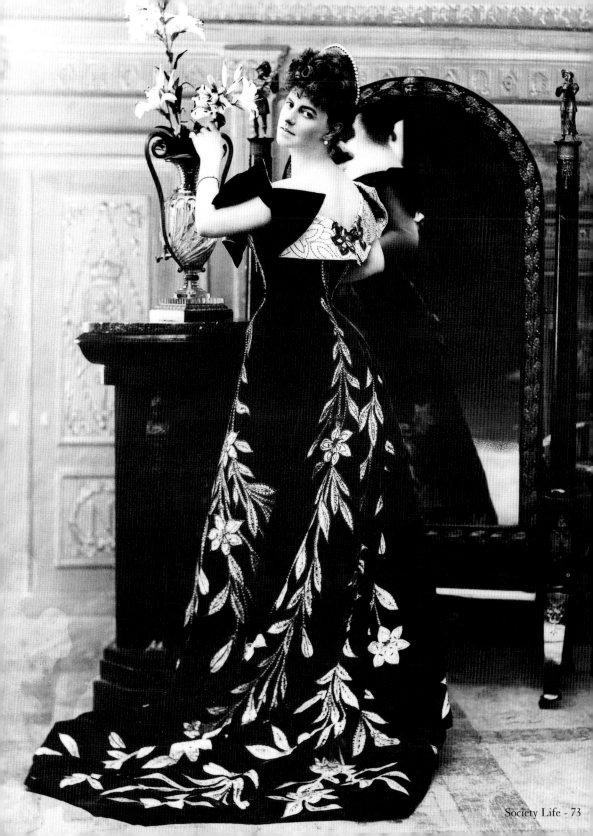

"For this photograph was like one encounter more, added to all those I had already had, with Mme. de Guermantes; better still, a prolonged encounter, as if […] she had stopped beside me […] and had allowed me for the first time to gaze at my leisure at that plump cheek, that arched neck, that tapering eyebrow […]."[44] This dress belonged to Mme. Tallien, Élisabeth's great-grandmother who, during the Revolution, had been dubbed "Our Lady of Thermidor."

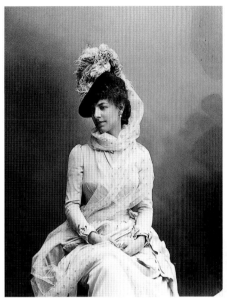

1886

According to a gossip column of the time, the Comtesse Greffulhe "despises [...] the commonplace. [...] Her outfits, invented for her or by her, must be like none other. [...] She seeks her inspiration at the Louvre, and her hair styles and her hats are often copies of the old masters' finest creations."[45] Whatever she might be wearing, she never gave up her supreme distinction.

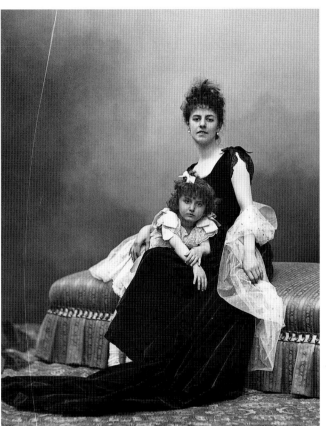

August 16th, 1886
Élisabeth Greffulhe and Élaine, her only daughter, at the age of four.

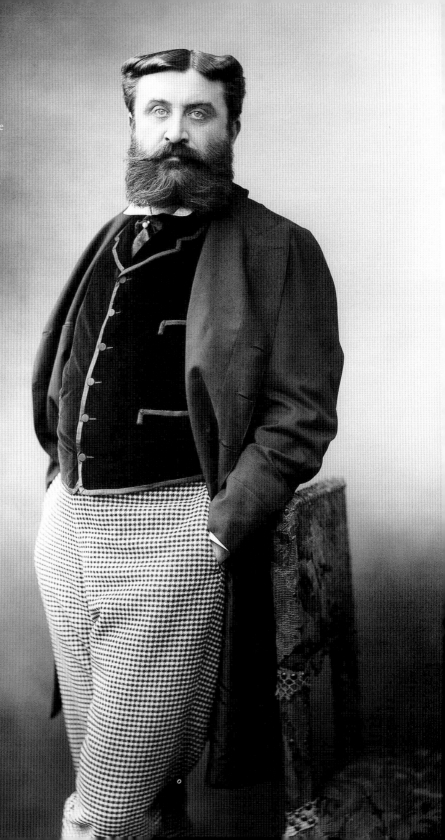

Comte Henry Greffulhe (1848-1932)

Fabulously rich, the heir of Belgian bankers and a friend of the Prince of Wales, the Comte Greffulhe married Élisabeth de Caraman-Chimay in 1878. He was a tall man with a blond beard whom Jacques-Émile Blanche likened to the king in a card game. Like the Duc de Guermantes*, this "thundering Jove" was a faithless, jealous husband, and he did not care much for the circle of friends of Montesquiou, his wife's beloved cousin. She was to confide to Abbé Mugnier: "A few friends […] you see from time to time, are a greater part of your life than 'the man snoring beside you.'"[46]

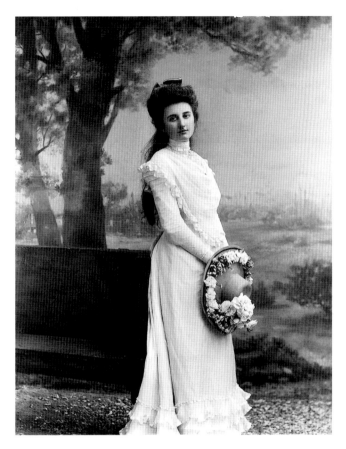

July 24th, 1900

Élaine Greffulhe
(1882-1958)

The daughter of the Comte and Comtesse Greffulhe, in 1904
she married the Duc de Guiche who, up to Proust's death,
remained the writer's loyal friend. The latter's wedding present,
a Gastinne-Renette revolver, was kept in a leather case decorated
with gouaches by Coco de Madrazo. These gouaches illustrated
some childhood poems by the young woman, who wrote with
talent and feeling. Her mother's self-conscious beauty kept her
out of the limelight in society. Proust saw her later at the parties
he gave at his parents', on the rue de Courcelles, and during his
stays in Cabourg, since the Guiches lived at the villa Mon rêve,
in Bénerville.

Charles Boson de Talleyrand-Périgord Prince de Sagan (1832-1910)

Boni de Castellane's uncle, this grand aristocrat and arbiter of elegance was a habitué of the foyer of the Comédie-Française – where it was appropriate to meet – with his friends Robert de Fitz-James, the Général de Galliffet, Charles Haas and Louis de Turenne. This Belle Époque Don Juan was the model for the Marquis de Priola, the eponymous hero of the comedy by Henri Lavedan (1902), and inspired several of the witticisms of the Duc de Guermantes and the Baron de Charlus.

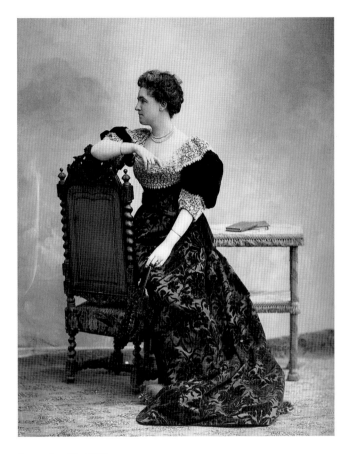

September 6th, 1892

Mme. Meredith Howland
née Adélaïde Torrance
(1849-1932)

One of the personalities whose company the faubourg Saint-Germain most prized (she entertained in her *hôtel particulier* on the rue de Berri), Adélaïde Howland was very close to Charles Haas and the painter Edgar Degas. She also enjoyed the rare privilege of being one of the few ladies to count among Robert de Montesquiou's friends. Proust, who met her during a stay at Saint-Moritz, dedicated the short story "Mme. de Breyves' melancholy holiday" (in *Pleasures and Regrets*) to her with these words: "To Madame Meredith Howland in respectful memory of the Engadine lakes and especially the lake of Silva Plana, Saint-Moritz, August '93."

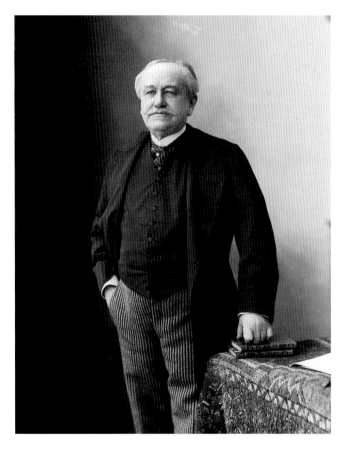

April 21st, 1890

Alain, Duc de Rohan

A member of the faubourg Saint-Germain aristocracy welcomed
in the Princesse Mathilde's salon, the Duc de Rohan would meet
there, among others, the Gramonts and the Comte de Turenne.
He inspired the character of the Duc de Guermantes; several
sallies of his entourage can be found in *Remembrance*.

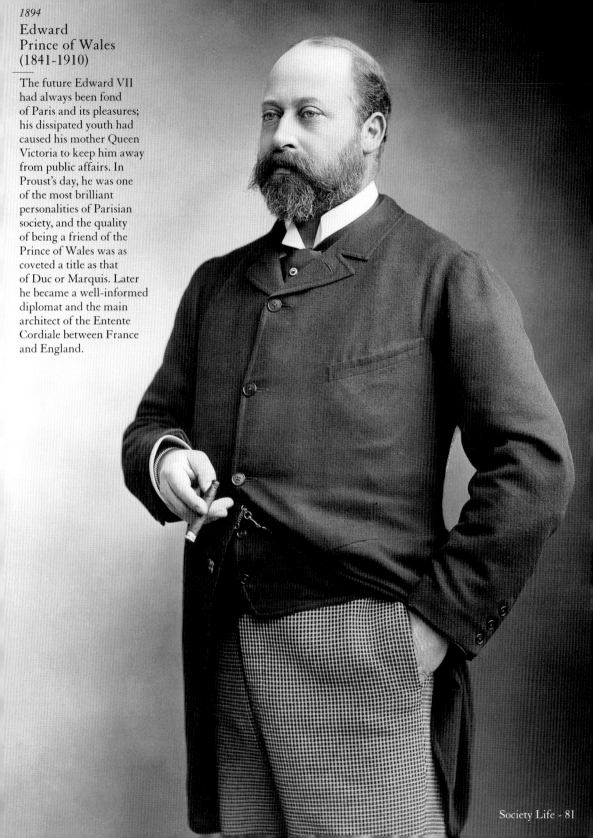

1894

Edward
Prince of Wales
(1841-1910)

The future Edward VII
had always been fond
of Paris and its pleasures;
his dissipated youth had
caused his mother Queen
Victoria to keep him away
from public affairs. In
Proust's day, he was one
of the most brilliant
personalities of Parisian
society, and the quality
of being a friend of the
Prince of Wales was as
coveted a title as that
of Duc or Marquis. Later
he became a well-informed
diplomat and the main
architect of the Entente
Cordiale between France
and England.

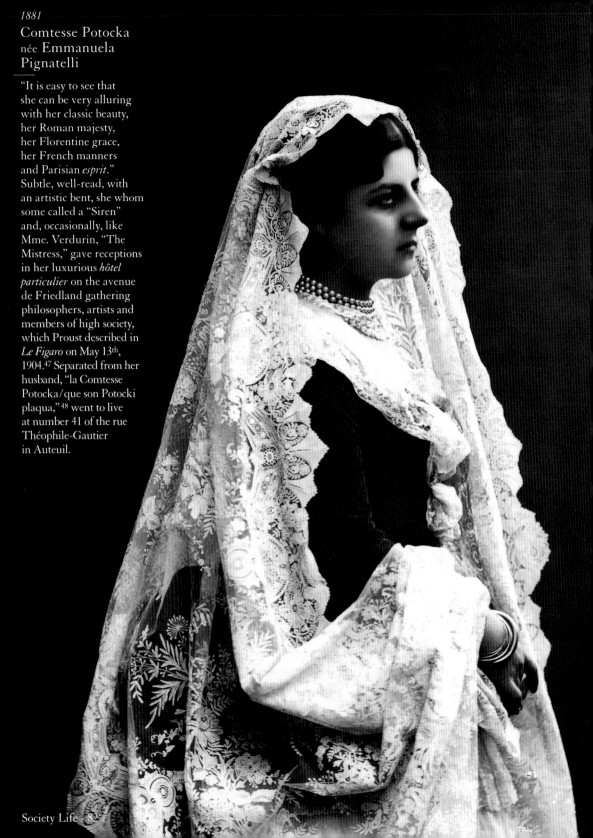

Comtesse Potocka
née Emmanuela
Pignatelli

"It is easy to see that
she can be very alluring
with her classic beauty,
her Roman majesty,
her Florentine grace,
her French manners
and Parisian *esprit*."
Subtle, well-read, with
an artistic bent, she whom
some called a "Siren"
and, occasionally, like
Mme. Verdurin, "The
Mistress," gave receptions
in her luxurious *hôtel
particulier* on the avenue
de Friedland gathering
philosophers, artists and
members of high society,
which Proust described in
Le Figaro on May 13th,
1904.[47] Separated from her
husband, "la Comtesse
Potocka/que son Potocki
plaqua,"[48] went to live
at number 41 of the rue
Théophile-Gautier
in Auteuil.

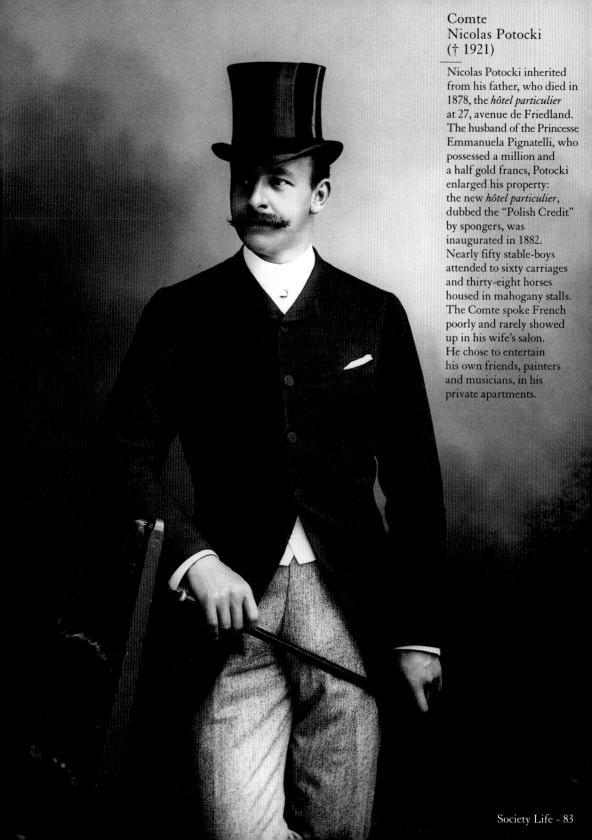

Comte
Nicolas Potocki
(† 1921)

Nicolas Potocki inherited from his father, who died in 1878, the *hôtel particulier* at 27, avenue de Friedland. The husband of the Princesse Emmanuela Pignatelli, who possessed a million and a half gold francs, Potocki enlarged his property: the new *hôtel particulier*, dubbed the "Polish Credit" by spongers, was inaugurated in 1882. Nearly fifty stable-boys attended to sixty carriages and thirty-eight horses housed in mahogany stalls. The Comte spoke French poorly and rarely showed up in his wife's salon. He chose to entertain his own friends, painters and musicians, in his private apartments.

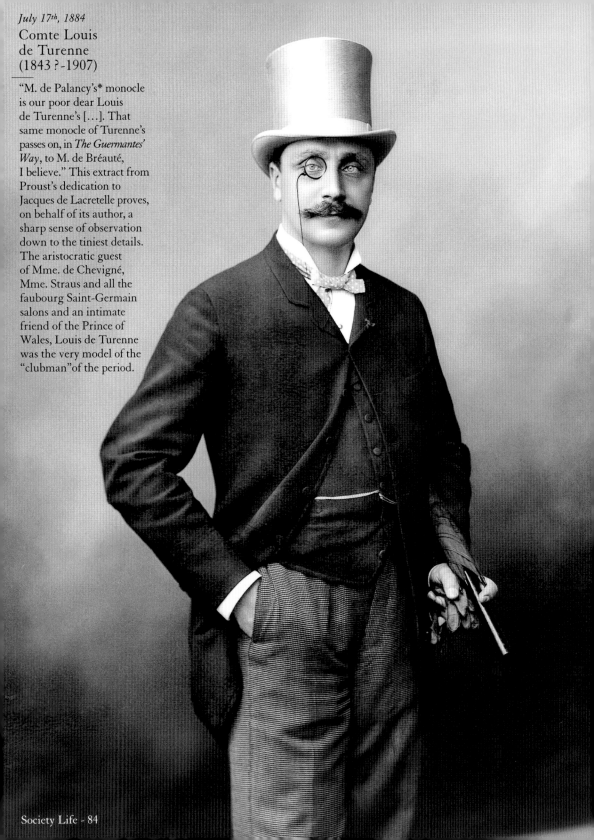

July 17th, 1884

Comte Louis
de Turenne
(1843 ?-1907)

"M. de Palancy's* monocle
is our poor dear Louis
de Turenne's […]. That
same monocle of Turenne's
passes on, in *The Guermantes'
Way*, to M. de Bréauté,
I believe." This extract from
Proust's dedication to
Jacques de Lacretelle proves,
on behalf of its author, a
sharp sense of observation
down to the tiniest details.
The aristocratic guest
of Mme. de Chevigné,
Mme. Straus and all the
faubourg Saint-Germain
salons and an intimate
friend of the Prince of
Wales, Louis de Turenne
was the very model of the
"clubman" of the period.

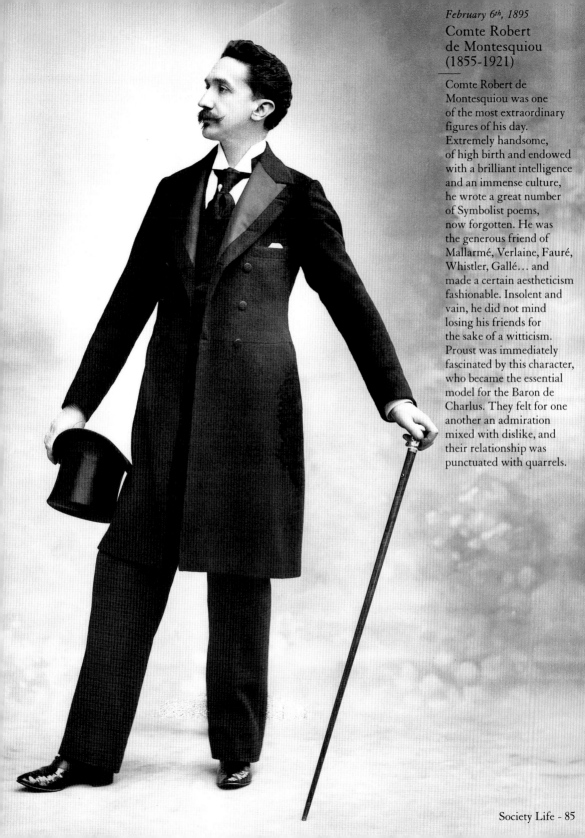

Comte Robert de Montesquiou (1855-1921)

Comte Robert de Montesquiou was one of the most extraordinary figures of his day. Extremely handsome, of high birth and endowed with a brilliant intelligence and an immense culture, he wrote a great number of Symbolist poems, now forgotten. He was the generous friend of Mallarmé, Verlaine, Fauré, Whistler, Gallé… and made a certain aestheticism fashionable. Insolent and vain, he did not mind losing his friends for the sake of a witticism. Proust was immediately fascinated by this character, who became the essential model for the Baron de Charlus. They felt for one another an admiration mixed with dislike, and their relationship was punctuated with quarrels.

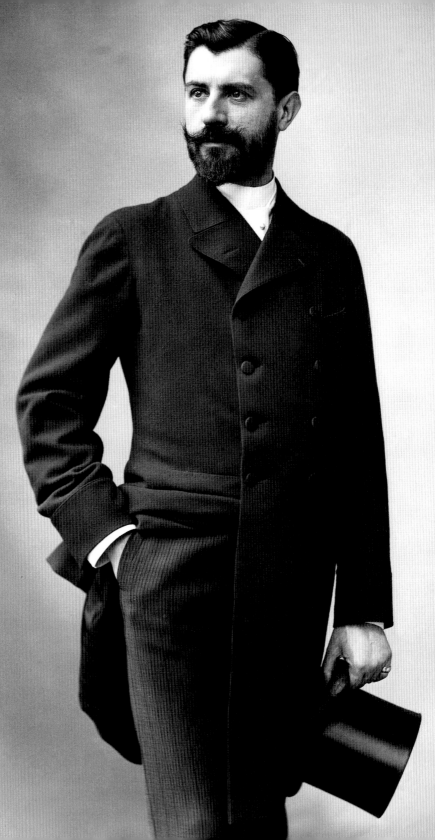

Doctor Samuel Pozzi (1846-1918)

Doctor Pozzi, an eminent surgeon who attentively kept up with medical progress, was received in the salons of the faubourg Saint-Germain. Leconte de Lisle, Montesquiou and Polignac were his intimates. He was handsome and charming, and his well-known infidelities had inspired Mme. Aubernon to call him "Doctor Love." Marcel Proust met him in 1886, when the physician was a guest of the schoolboy's parents, and it was to him that he owed his first "dining out." Robert Proust, who held him in great esteem, was his assistant at the Broca hospital. He died in 1918, assassinated by a patient who had gone insane.

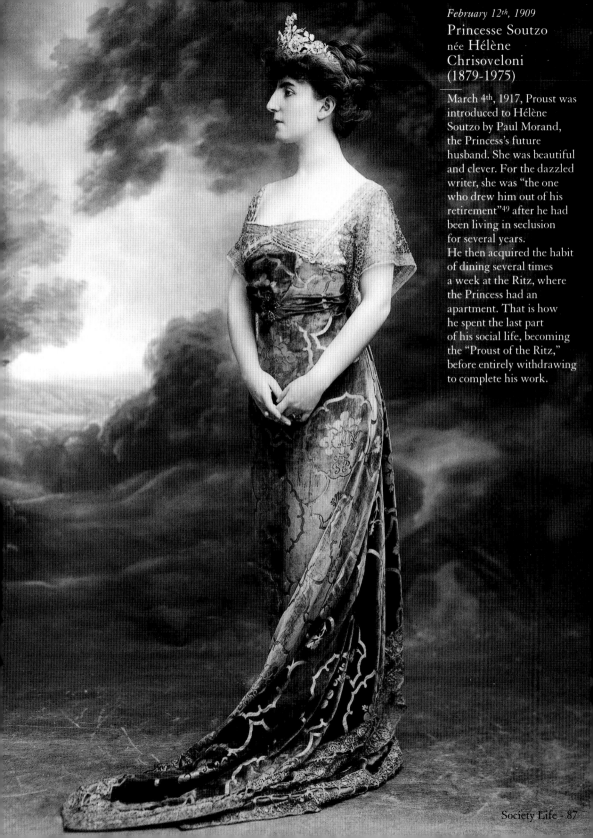

Princesse Soutzo
née Hélène
Chrisoveloni
(1879-1975)

March 4th, 1917, Proust was
introduced to Hélène
Soutzo by Paul Morand,
the Princess's future
husband. She was beautiful
and clever. For the dazzled
writer, she was "the one
who drew him out of his
retirement"[49] after he had
been living in seclusion
for several years.
He then acquired the habit
of dining several times
a week at the Ritz, where
the Princess had an
apartment. That is how
he spent the last part
of his social life, becoming
the "Proust of the Ritz,"
before entirely withdrawing
to complete his work.

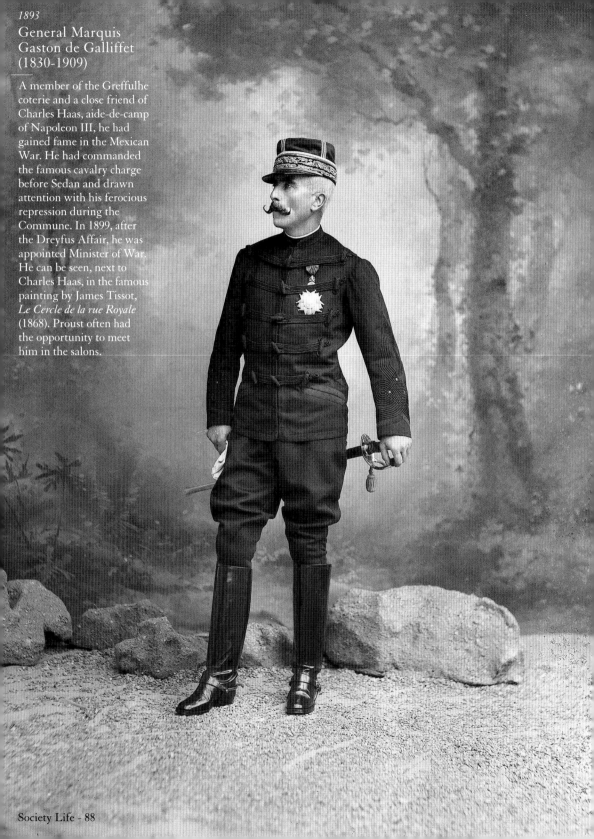

1893

General Marquis Gaston de Galliffet (1830-1909)

A member of the Greffulhe coterie and a close friend of Charles Haas, aide-de-camp of Napoleon III, he had gained fame in the Mexican War. He had commanded the famous cavalry charge before Sedan and drawn attention with his ferocious repression during the Commune. In 1899, after the Dreyfus Affair, he was appointed Minister of War. He can be seen, next to Charles Haas, in the famous painting by James Tissot, *Le Cercle de la rue Royale* (1868). Proust often had the opportunity to meet him in the salons.

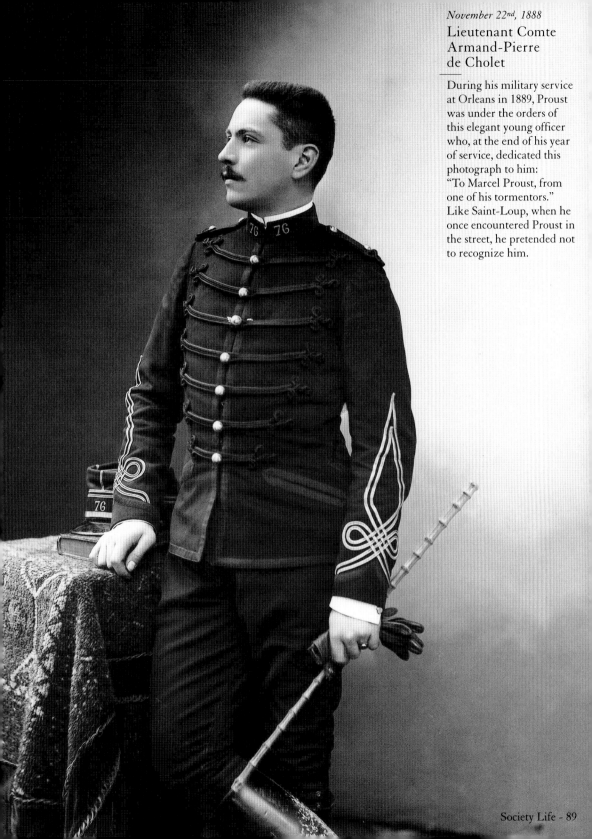

November 22nd, 1888

Lieutenant Comte
Armand-Pierre
de Cholet

During his military service
at Orleans in 1889, Proust
was under the orders of
this elegant young officer
who, at the end of his year
of service, dedicated this
photograph to him:
"To Marcel Proust, from
one of his tormentors."
Like Saint-Loup, when he
once encountered Proust in
the street, he pretended not
to recognize him.

From the very start, Proust took sides with Dreyfus and Zola at the time of the Affair, just as, ten years later, he would support Barrès in his efforts on behalf of the churches abandoned as a result of the laws of the "petit père" Combes – undoubtedly keeping in mind his annotated translation of Ruskin's *Bible of Amiens*.

Encouraged by Anatole France, whom he had asked to write a preface for *Pleasures and Regrets* in 1896, Proust began publishing *Remembrance*, at his own expense, with Grasset, until Léon Daudet's and Jacques Rivière's recommendations gave him access to the newly founded Éditions de la Nouvelle Revue Française in 1913. In 1919, he won the Prix Goncourt.

Fascinated by both the theater and music, Proust was acquainted with the composers and performers of the Belle Époque. *Remembrance* is full of references to these bonds, transformed by his ironic, fond pen.

1894
A great figure in Proust's life and work (under the name of La Berma*),
Sarah Bernhardt went regularly to the Nadars' to pose in her stage costumes,
replicating the gestures, attitudes and expressions of her stage roles.
Here she is Izeïl, in the drama of the same name by Silvestre and Morand.
This shot discloses technical details of the studio: the light coming in from
windows on the sides and overhead is diffused by curtains made of light
fabric on sliding rods.

Georges
de Porto-Riche
(1849-1930)

A playwright, his plays
dealt exclusively with the
depiction of passionate
love, eight of them forming
what he himself called his
"love theater." Réjane
played in *Amoureuse* in
1891; *Le Passé* was first
performed in 1897. He was
a frequent visitor in the
salons of the Princesse
Mathilde, Mme. Aubernon,
Mme. Straus and
the Princesse Alexandre
Bibesco and had been
a guest of Proust's.
In 1906, he was appointed
Administrator of
the Mazarine library,
where Proust had spent
some time as an assistant.

October 1905

Louisa de Mornand
(1884-1963)

In 1903, Proust made the acquaintance of this charming actress at the same time as that of Louis d'Albuféra, whose mistress she was. He soon developed feelings for her that she recalled twenty years later: "Ours was an *amitié amoureuse*, in which there was no element of a banal flirtation nor of an exclusive liaison, but on Proust's side, a strong passion tinged with affection and desire, and on mine an attachment that was more than comradeship and really touched my heart."[50]

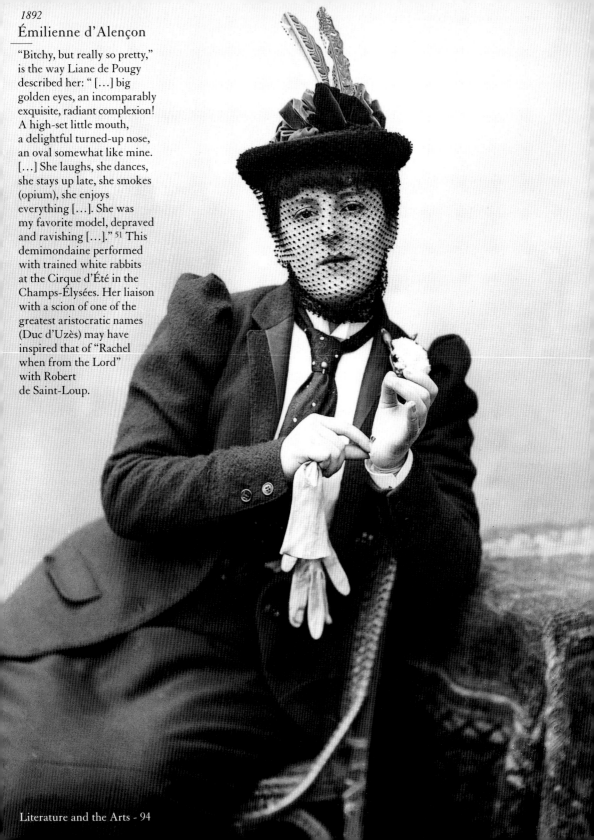

1892

Émilienne d'Alençon

"Bitchy, but really so pretty," is the way Liane de Pougy described her: " [...] big golden eyes, an incomparably exquisite, radiant complexion! A high-set little mouth, a delightful turned-up nose, an oval somewhat like mine. [...] She laughs, she dances, she stays up late, she smokes (opium), she enjoys everything [...]. She was my favorite model, depraved and ravishing [...]." [51] This demimondaine performed with trained white rabbits at the Cirque d'Été in the Champs-Élysées. Her liaison with a scion of one of the greatest aristocratic names (Duc d'Uzès) may have inspired that of "Rachel when from the Lord" with Robert de Saint-Loup.

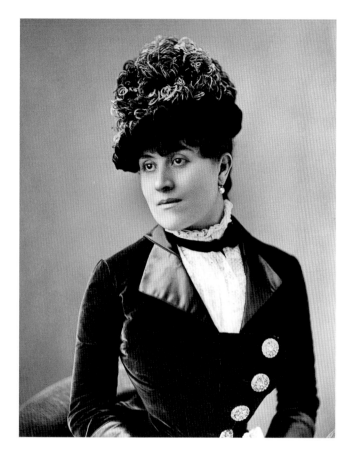

November 25th, 1879

Laure Hayman
(1851-1932)

Proust met Laure Hayman at his maternal great-uncle's. He was
seventeen at the time, and because of his pink porcelain
complexion, she called him "my little psychological Saxe."
This courtesan entertained Dukes, "clubmen" and writers. Paul
Bourget, one of her many lovers, described her in his short story
"Gladys Harvey." She was one of Proust's sources for the character
of Odette de Crécy, but unlike Swann's mistress, she was
a sensitive, intelligent and cultured woman who later took up
sculpture. She offered to decorate Dr. Proust's tomb, and Robert
wrote: "That way it will be sweet to have a bust of Papa made by
someone in the family."[52]

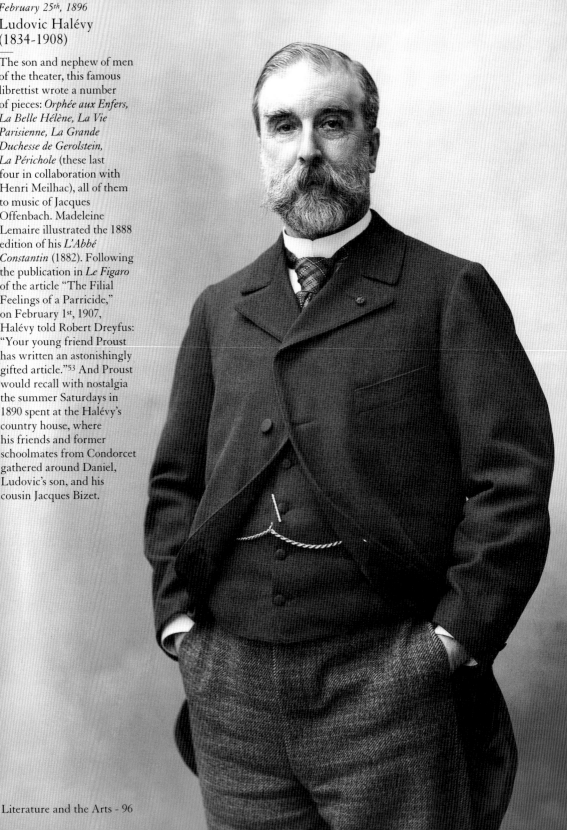

February 25th, 1896

Ludovic Halévy
(1834-1908)

The son and nephew of men of the theater, this famous librettist wrote a number of pieces: *Orphée aux Enfers, La Belle Hélène, La Vie Parisienne, La Grande Duchesse de Gerolstein, La Périchole* (these last four in collaboration with Henri Meilhac), all of them to music of Jacques Offenbach. Madeleine Lemaire illustrated the 1888 edition of his *L'Abbé Constantin* (1882). Following the publication in *Le Figaro* of the article "The Filial Feelings of a Parricide," on February 1st, 1907, Halévy told Robert Dreyfus: "Your young friend Proust has written an astonishingly gifted article."[53] And Proust would recall with nostalgia the summer Saturdays in 1890 spent at the Halévy's country house, where his friends and former schoolmates from Condorcet gathered around Daniel, Ludovic's son, and his cousin Jacques Bizet.

April 21st, 1887

Mme. Émile Straus
née Geneviève Halévy
(1849-1926)

Ludovic Halévy's first
cousin, Mme. Straus had
first married the composer
Georges Bizet. As a young
widow, she consulted her
son Jacques – a great friend
of Proust's – before
remarrying, this time
to Émile Straus,
the Rothschild's lawyer.
Intelligent and generous
with magnificent black eyes,
Mme. Straus was a very
good friend of Proust's all
her life, as we can see in
their vast correspondence.
Her salon on the rue de
Miromesnil drew the world
of literature, art and
elegance. The "Guermantes
esprit" is largely that
of Mme. Straus.

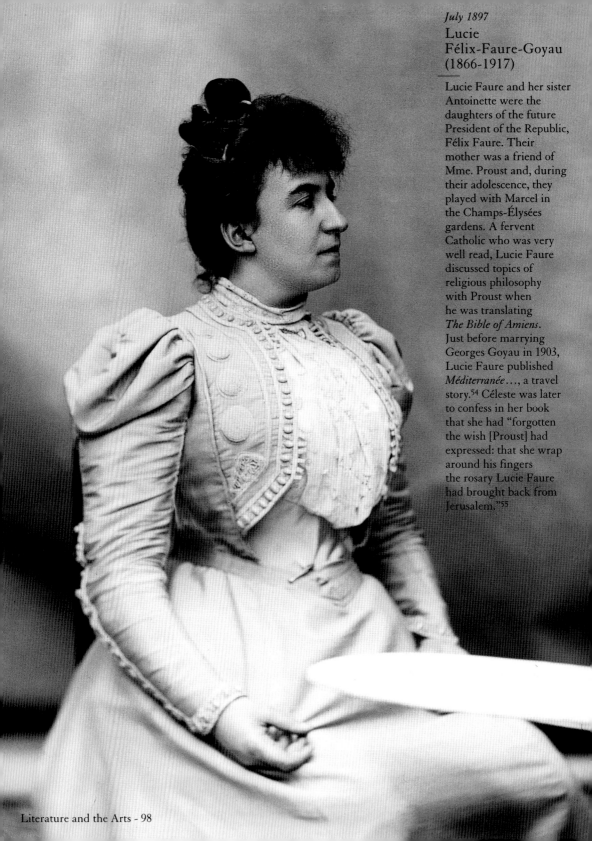

Lucie Félix-Faure-Goyau (1866-1917)

Lucie Faure and her sister Antoinette were the daughters of the future President of the Republic, Félix Faure. Their mother was a friend of Mme. Proust and, during their adolescence, they played with Marcel in the Champs-Élysées gardens. A fervent Catholic who was very well read, Lucie Faure discussed topics of religious philosophy with Proust when he was translating *The Bible of Amiens*. Just before marrying Georges Goyau in 1903, Lucie Faure published *Méditerranée...*, a travel story.[54] Céleste was later to confess in her book that she had "forgotten the wish [Proust] had expressed: that she wrap around his fingers the rosary Lucie Faure had brought back from Jerusalem."[55]

April 27th, 1889

Paul Desjardins
(1859-1940)

Proust had attended Paul Desjardins' philosophy lessons while
studying for his law degree; through him he discovered the
English writer John Ruskin. This professor of the Michelet and
Condorcet, Sèvres and Saint-Cloud lycées wrote for the *Journal des
Débats*, *Le Figaro* and *La Revue Bleue*. In 1892, in opposition to
the Decadent vogue, he founded the Union pour l'Action Morale
(which in 1904 became Union pour la Vérité), whose journal
would publish the first Ruskin translations. In 1910, he created
the "Decades" of the Abbaye de Pontigny: these debates, which
so interested Proust that he often made plans to attend them,
were summarized in the *Bulletin de l'Union pour la Vérité*.
The Decades were perpetuated by Paul Desjardin's daughter
and in 1962 were devoted to Marcel Proust.

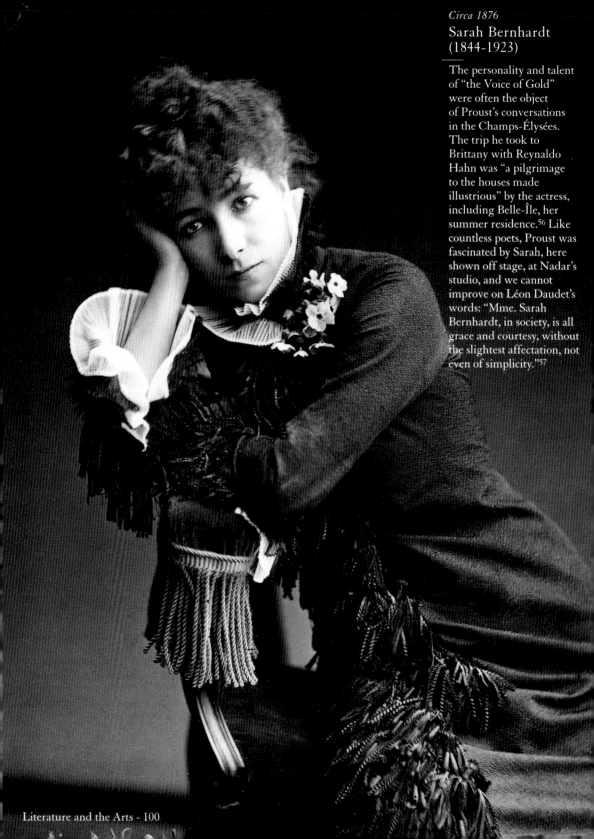

Sarah Bernhardt
(1844-1923)

The personality and talent of "the Voice of Gold" were often the object of Proust's conversations in the Champs-Élysées. The trip he took to Brittany with Reynaldo Hahn was "a pilgrimage to the houses made illustrious" by the actress, including Belle-Île, her summer residence.[56] Like countless poets, Proust was fascinated by Sarah, here shown off stage, at Nadar's studio, and we cannot improve on Léon Daudet's words: "Mme. Sarah Bernhardt, in society, is all grace and courtesy, without the slightest affectation, not even of simplicity."[57]

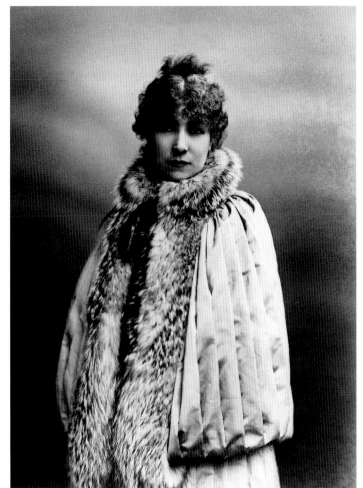

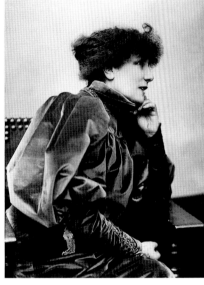

Above, Sarah, in *1883*, as Fédora, the title
role of Sardou's melodrama (1882); above
right, circa *1888*, "Sarah is there […],
with her tantalizing, delicate profile,
her cold sparkling eyes, like precious
stones […], swaying and stirring under
her shimmering metal belt;"[58] right,
in 1890, in town dress, with Persian lamb
toque and coat.

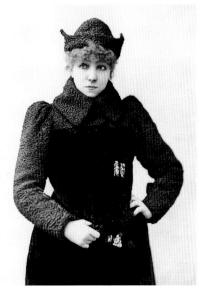

Sarah in *Phèdre* by Racine.
If the first – long-awaited –
encounter of the Narrator
of *Remembrance* with the
performer of *Phèdre* was
a "disappointment," at
the second, "the talent
of Berma" "imposed itself
on [his] admiration. […]
the voice […] had been
brought to an exquisite
perfection in each of
its tiniest cells like the
instrument of a master
violinist, in whom one
means, when one says
that his music has a fine
sound, to praise not a
physical peculiarity
but a superiority of
soul." [59]

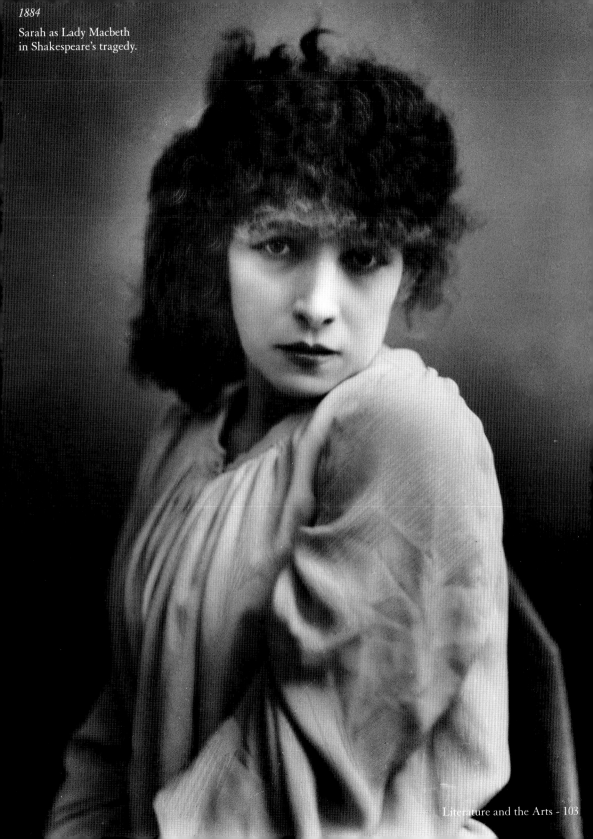

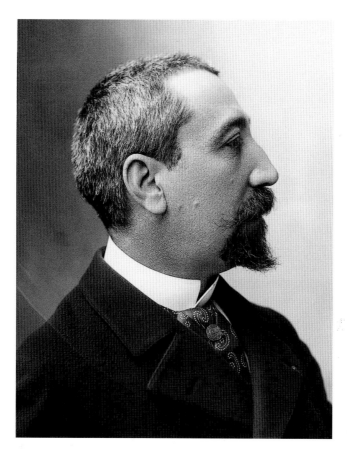

1893

Anatole France
(1844-1924)

In 1889, Proust was introduced to the salon of Mme. Arman
de Caillavet, the Egeria of Anatole France. The youth's intense
admiration for the writer went back to his schooldays. Out of
friendship for Proust, France wrote the preface to *Pleasures and
Regrets*, a work whose style points to the influence of the author
of the *Lys Rouge* on the younger writer. Many of Anatole France's
traits can be found in Bergotte*.

Paul Hervieu
(1857-1915)

Destined for a political career, Paul Hervieu lost interest in it and in 1878 turned to literature. Under the pen name Éliacin, he published several short stories and then, under his real name, successful novels (*Flirt*, 1890, *Peints par eux-mêmes*, 1893) and somber dramas performed at the Théâtre Français (as of 1892) and the Vaudeville. The name Doncières, given to a character in his *Connais-toi* (1909), provided Proust with the name of the small garrison-town of *Remembrance*. In the salons Hervieu affected an icy elegance, an air of mournful distinction. Proust recalled feeling guilty for not having forgiven the Academician (elected in 1900) for his vote against *Swann's Way* for the Académie Française award in June 1914.

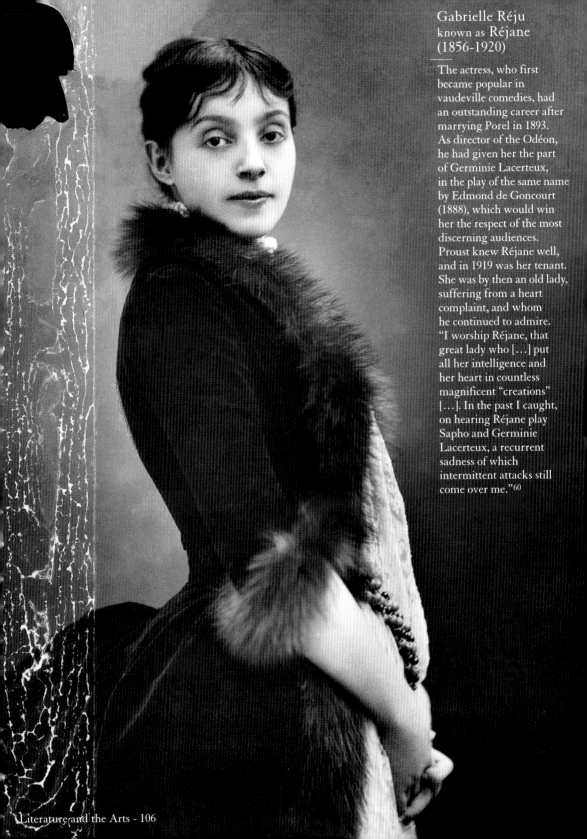

Gabrielle Réju
known as Réjane
(1856-1920)

The actress, who first
became popular in
vaudeville comedies, had
an outstanding career after
marrying Porel in 1893.
As director of the Odéon,
he had given her the part
of Germinie Lacerteux,
in the play of the same name
by Edmond de Goncourt
(1888), which would win
her the respect of the most
discerning audiences.
Proust knew Réjane well,
and in 1919 was her tenant.
She was by then an old lady,
suffering from a heart
complaint, and whom
he continued to admire.
"I worship Réjane, that
great lady who […] put
all her intelligence and
her heart in countless
magnificent "creations"
[…]. In the past I caught,
on hearing Réjane play
Sapho and Germinie
Lacerteux, a recurrent
sadness of which
intermittent attacks still
come over me."[60]

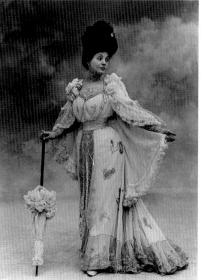

Above left, Réjane with her daughter
Germaine Porel, in *1896*; above, in *1889*,
in the part of Germinie Lacerteux;
left, in *1898*, in the comedy by Berton and
Simon, in a stage costume created by Paul
Poiret, at the time designer at Doucet's.

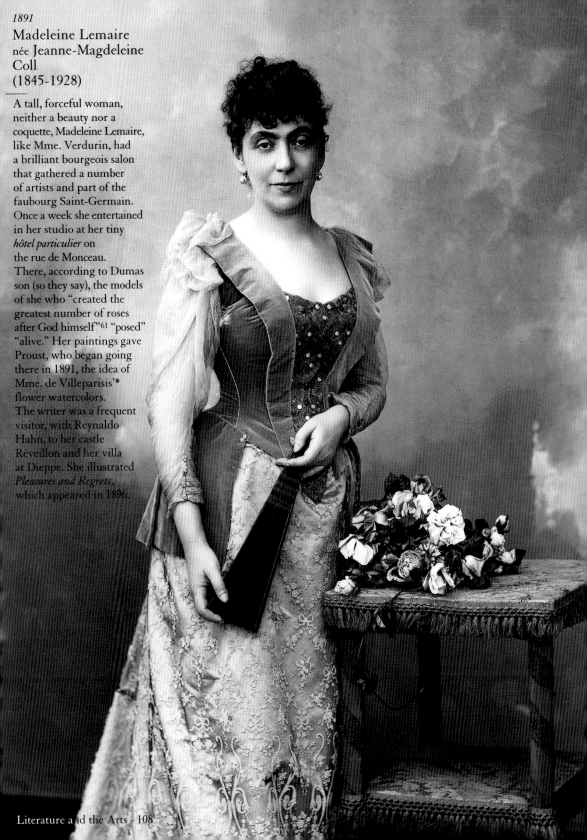

1891

Madeleine Lemaire
née Jeanne-Magdeleine Coll
(1845-1928)

A tall, forceful woman, neither a beauty nor a coquette, Madeleine Lemaire, like Mme. Verdurin, had a brilliant bourgeois salon that gathered a number of artists and part of the faubourg Saint-Germain. Once a week she entertained in her studio at her tiny *hôtel particulier* on the rue de Monceau. There, according to Dumas son (so they say), the models of she who "created the greatest number of roses after God himself"[61] "posed" "alive." Her paintings gave Proust, who began going there in 1891, the idea of Mme. de Villeparisis'* flower watercolors. The writer was a frequent visitor, with Reynaldo Hahn, to her castle Réveillon and her villa at Dieppe. She illustrated *Pleasures and Regrets*, which appeared in 1896.

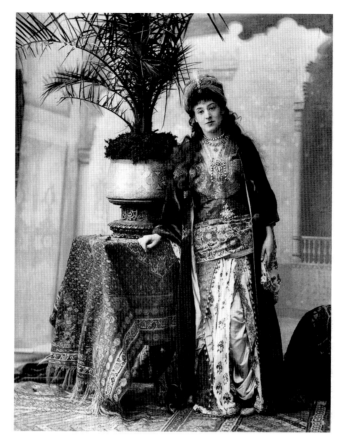

1885

Julia Bartet
(1854-1941)

A member of the Comédie-Française, she was called "the Divine" because of her incomparable diction, grace and charm.

She recited several stanzas of *Les Chauves-Souris*, a book of lyrical poems by Robert de Montesquiou, at one of Madeleine Lemaire's soirées, on March 28th, 1893.

Here, she appears in the part of Roxane in Racine's *Bajazet*, but her most famous part was Andromaque.

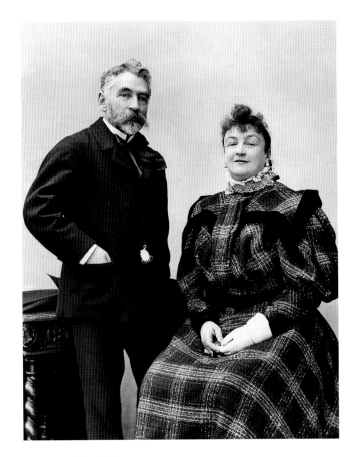

February 25th, 1896
Stéphane Mallarmé
(1842-1898)
Méry Laurent
(1849-1900)

In 1897, Proust was introduced by Reynaldo Hahn to Méry
Laurent's salon, where he often went with Marie Nordlinger.
The hostess had gathered a group of talented, clever men, such
as François Coppée, Henry Becque, Henri Gervex and Édouard
Manet, for whom she modeled. She may have provided a few
features for Odette de Crécy – "Miss Sacripant" – painted
by Elstir* in masculine attire, as Manet did occasionally.
Méry Laurent entertained Mallarmé in a welcoming, friendly,
relaxed atmosphere. Giving her some botanical information
one day, the poet added ironically: "This will give you
a chance of showing off your knowledge in front of Proust."[62]
The construction of *Remembrance* seems to respond to
the aspiration expressed by Mallarmé, who was one of Proust's
most heeded masters: "[…] so then the work becomes at once
architecture, painting and music."[63]

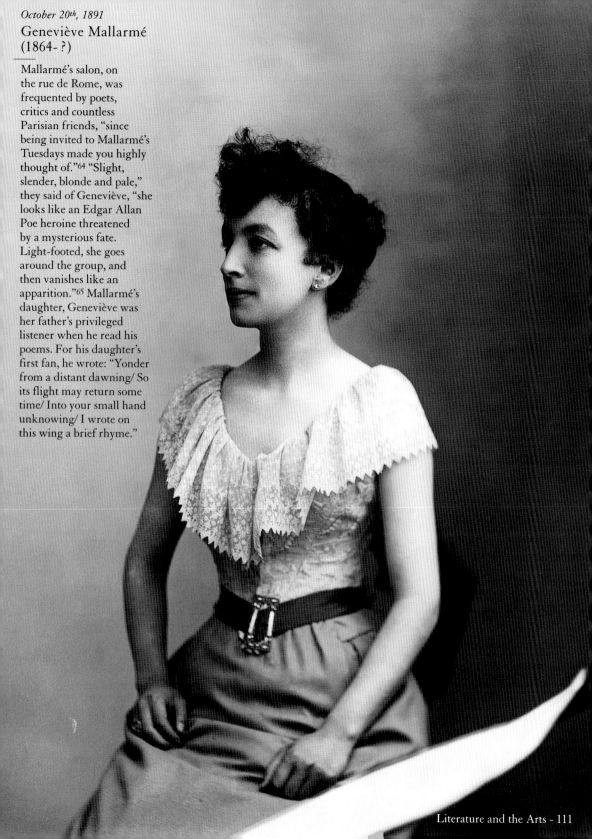

October 20th, 1891

Geneviève Mallarmé
(1864- ?)

Mallarmé's salon, on the rue de Rome, was frequented by poets, critics and countless Parisian friends, "since being invited to Mallarmé's Tuesdays made you highly thought of."[64] "Slight, slender, blonde and pale," they said of Geneviève, "she looks like an Edgar Allan Poe heroine threatened by a mysterious fate. Light-footed, she goes around the group, and then vanishes like an apparition."[65] Mallarmé's daughter, Geneviève was her father's privileged listener when he read his poems. For his daughter's first fan, he wrote: "Yonder from a distant dawning/ So its flight may return some time/ Into your small hand unknowing/ I wrote on this wing a brief rhyme."

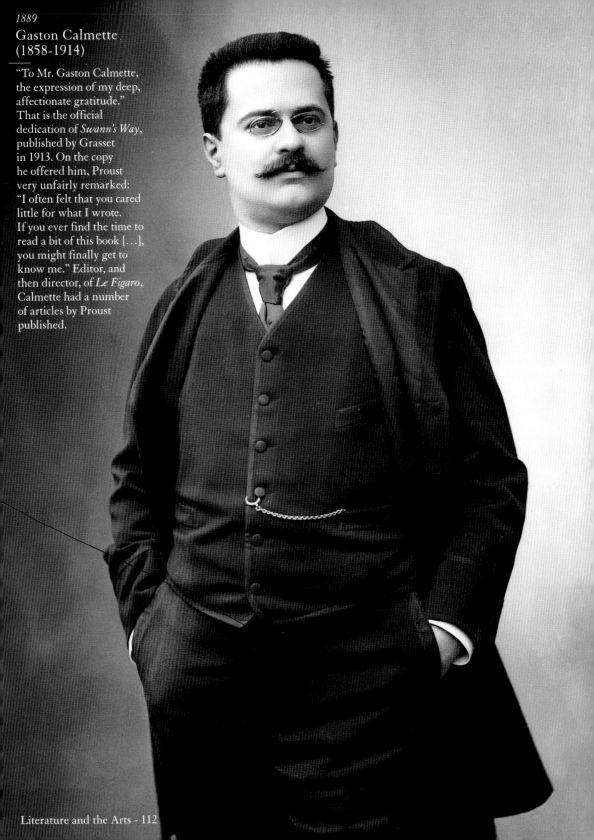

Gaston Calmette
(1858-1914)

"To Mr. Gaston Calmette, the expression of my deep, affectionate gratitude." That is the official dedication of *Swann's Way*, published by Grasset in 1913. On the copy he offered him, Proust very unfairly remarked: "I often felt that you cared little for what I wrote. If you ever find the time to read a bit of this book [...], you might finally get to know me." Editor, and then director, of *Le Figaro*, Calmette had a number of articles by Proust published.

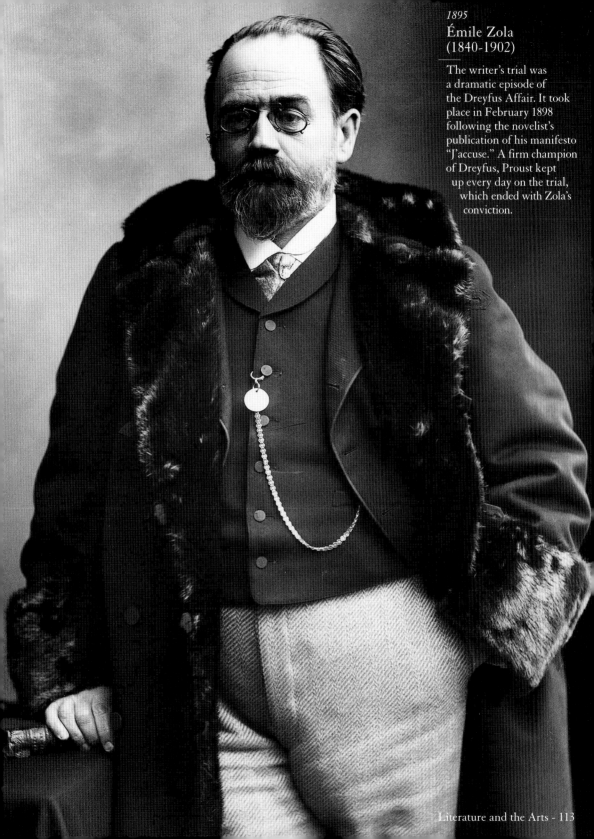

1895

Émile Zola
(1840-1902)

The writer's trial was
a dramatic episode of
the Dreyfus Affair. It took
place in February 1898
following the novelist's
publication of his manifesto
"J'accuse." A firm champion
of Dreyfus, Proust kept
up every day on the trial,
which ended with Zola's
conviction.

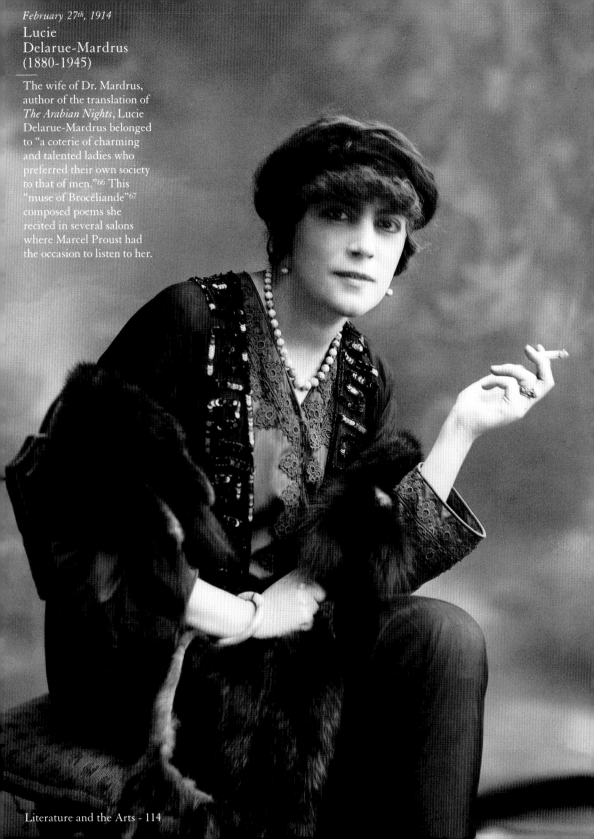

Lucie Delarue-Mardrus (1880-1945)

The wife of Dr. Mardrus, author of the translation of *The Arabian Nights*, Lucie Delarue-Mardrus belonged to "a coterie of charming and talented ladies who preferred their own society to that of men."[66] This "muse of Brocéliande"[67] composed poems she recited in several salons where Marcel Proust had the occasion to listen to her.

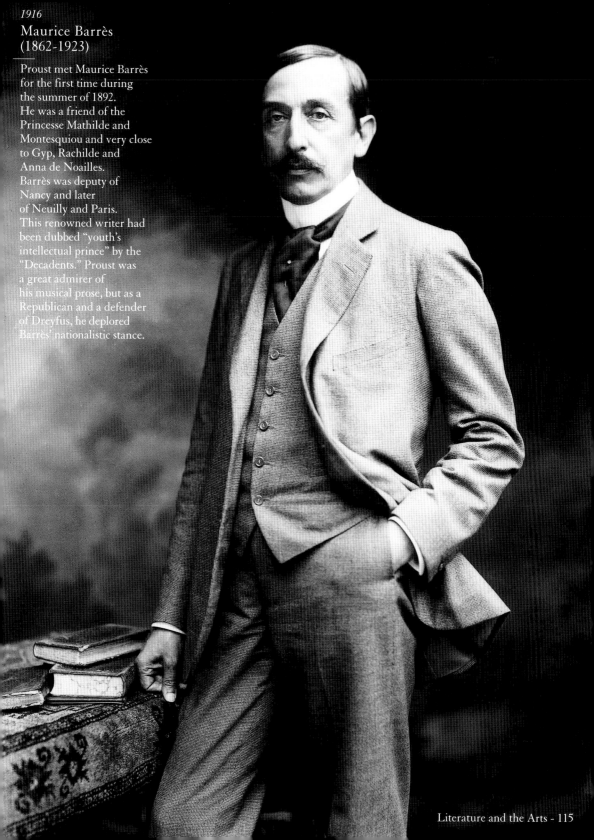

1916

Maurice Barrès
(1862-1923)

Proust met Maurice Barrès
for the first time during
the summer of 1892.
He was a friend of the
Princesse Mathilde and
Montesquiou and very close
to Gyp, Rachilde and
Anna de Noailles.
Barrès was deputy of
Nancy and later
of Neuilly and Paris.
This renowned writer had
been dubbed "youth's
intellectual prince" by the
"Decadents." Proust was
a great admirer of
his musical prose, but as a
Republican and a defender
of Dreyfus, he deplored
Barrès' nationalistic stance.

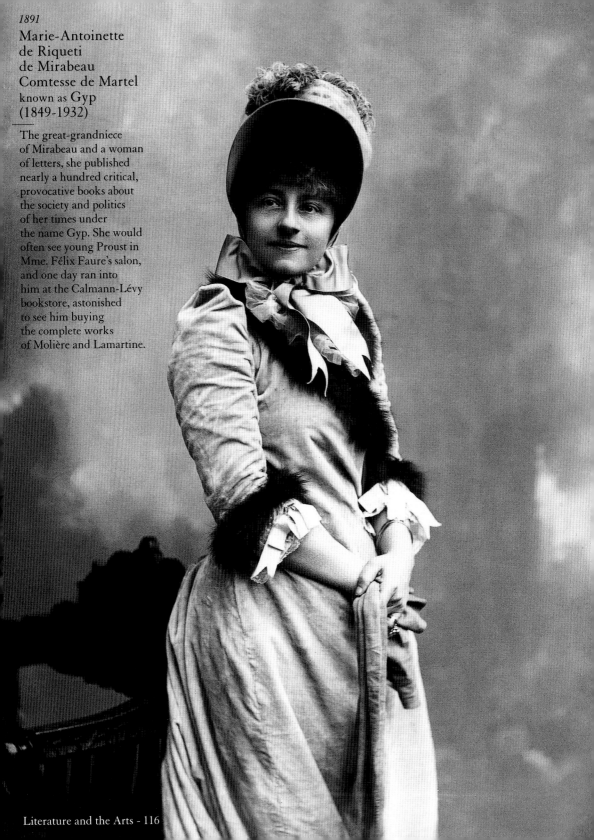

1891

Marie-Antoinette de Riqueti de Mirabeau Comtesse de Martel known as Gyp (1849-1932)

The great-grandniece of Mirabeau and a woman of letters, she published nearly a hundred critical, provocative books about the society and politics of her times under the name Gyp. She would often see young Proust in Mme. Félix Faure's salon, and one day ran into him at the Calmann-Lévy bookstore, astonished to see him buying the complete works of Molière and Lamartine.

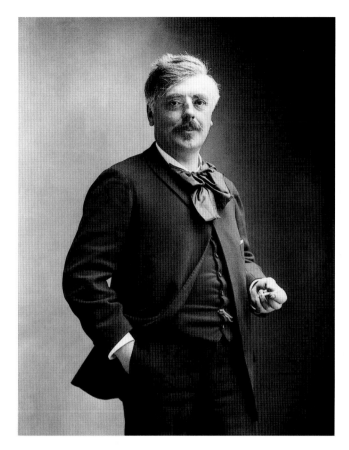

1893

Professor Édouard Brissaud
(1852-1909)

"Our dear *médecin malgré lui*, on whom one almost has to use physical force to get him to talk medicine,"[68] Marcel Proust wrote of Professor Brissaud, who was fond of discussing literature. This eminent neurologist, founder of the *Revue neurologique*, published many works, including *Hygiene for Asthmatics*, a book that was part of a series directed by Professor Proust, and which the latter had prefaced. His son Marcel kept it on his bedside table.

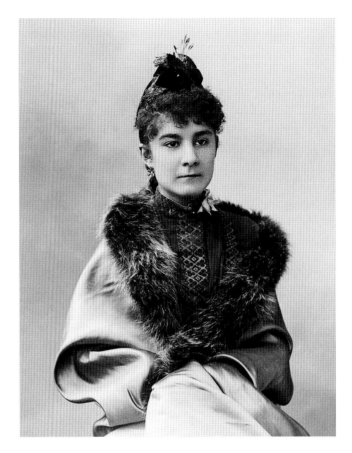

April 18th, 1889

Marie de Heredia
(1875-1963)

The youngest daughter of José Maria de Heredia, Marie, "parodying the campaign launched for her father's election at the Académie Française" (1894), had set up a group of friends, "the Kanak Academy," gathering among others Pierre Louÿs, Paul Valéry, Fernand Gregh, Léon Blum and Henri de Régnier (whom she married in 1895). Marie was the "Queen of the Academy" and Proust its "Perpetual Secretary."[69] She left several novels, including *Le Temps d'Aimer* (1908) and *Esclave amoureuse* (1927), published under the name Gérard d'Houville.

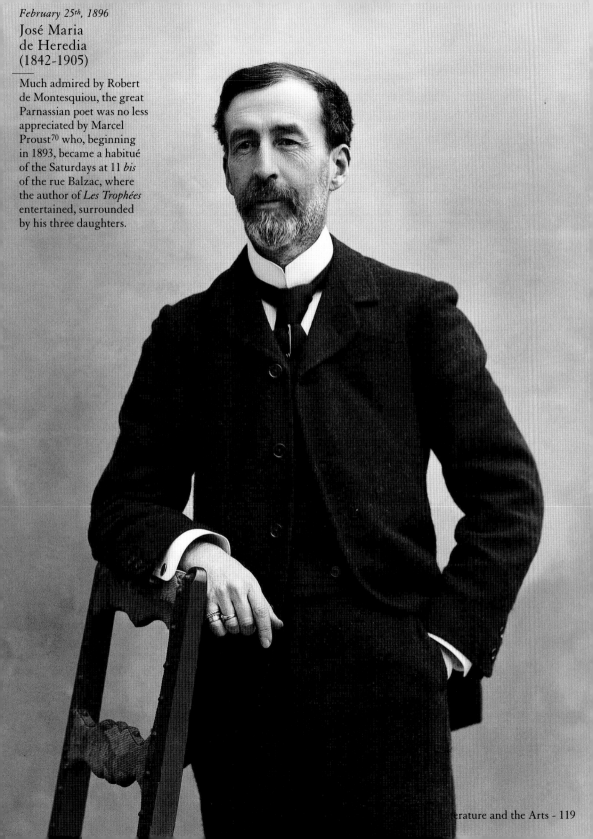

José Maria
de Heredia
(1842-1905)

Much admired by Robert
de Montesquiou, the great
Parnassian poet was no less
appreciated by Marcel
Proust[70] who, beginning
in 1893, became a habitué
of the Saturdays at 11 *bis*
of the rue Balzac, where
the author of *Les Trophées*
entertained, surrounded
by his three daughters.

April 1903
Abel Hermant
(1862-1950)

A novelist and drama critic at *Gil Blas* and *Le Figaro*, Abel Hermant was also an excellent satirical chronicler of the bourgeois mores of his times (*Mémoires pour servir à l'histoire de la société*, 1901-1937). A champion of the French language (his stylistic studies fill several volumes), he is the author of *Grammaire de l'Académie Française* (1932). An intimate of the Princesse Rachel de Brancovan's children (Anna de Noailles, Hélène de Caraman-Chimay and Constantin de Brancovan, all three friends of Proust), Hermant often had the occasion to meet him, not just in Paris, but also in Amphion on Lake Geneva, where the Princesse Rachel entertained in her villa Bassaraba.

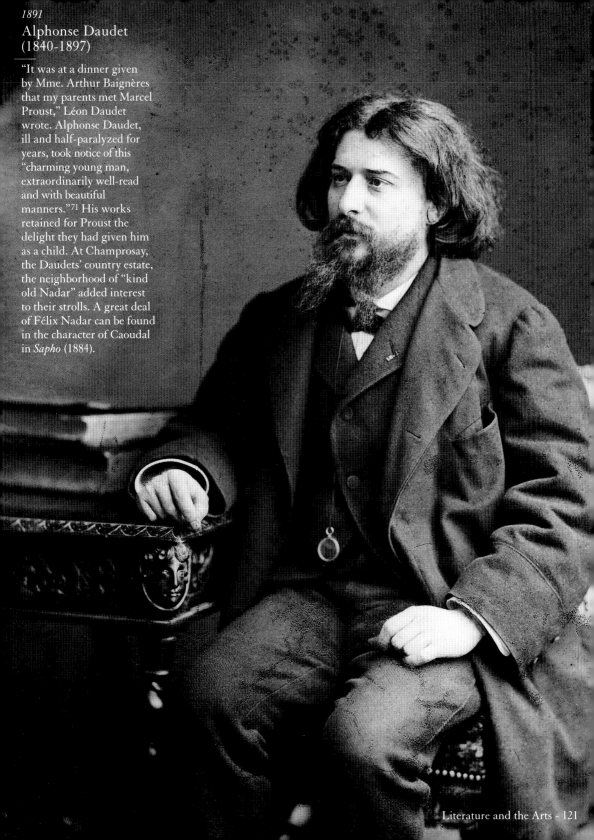

Alphonse Daudet
(1840-1897)

"It was at a dinner given by Mme. Arthur Baignères that my parents met Marcel Proust," Léon Daudet wrote. Alphonse Daudet, ill and half-paralyzed for years, took notice of this "charming young man, extraordinarily well-read and with beautiful manners."[71] His works retained for Proust the delight they had given him as a child. At Champrosay, the Daudets' country estate, the neighborhood of "kind old Nadar" added interest to their strolls. A great deal of Félix Nadar can be found in the character of Caoudal in *Sapho* (1884).

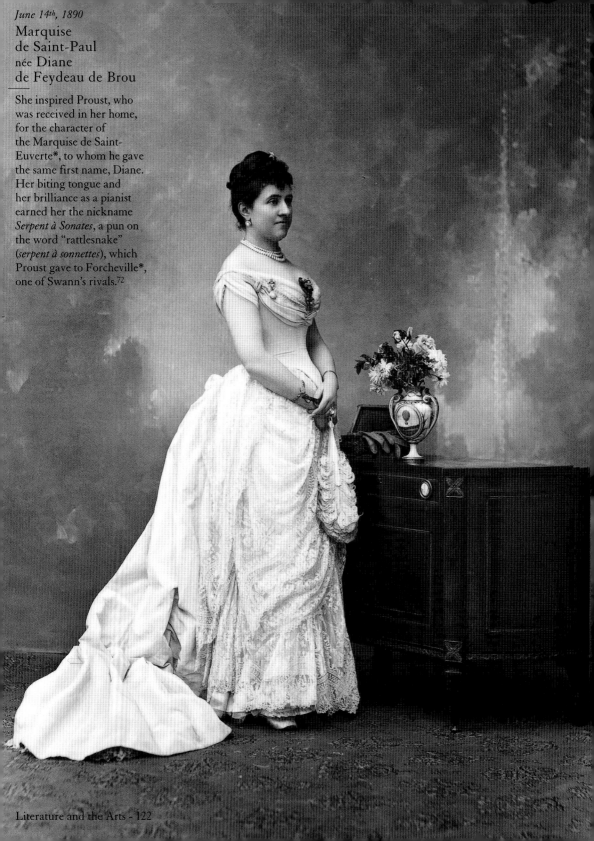

June 14th, 1890

Marquise de Saint-Paul née Diane de Feydeau de Brou

She inspired Proust, who was received in her home, for the character of the Marquise de Saint-Euverte*, to whom he gave the same first name, Diane. Her biting tongue and her brilliance as a pianist earned her the nickname *Serpent à Sonates*, a pun on the word "rattlesnake" (*serpent à sonnettes*), which Proust gave to Forcheville*, one of Swann's rivals.[72]

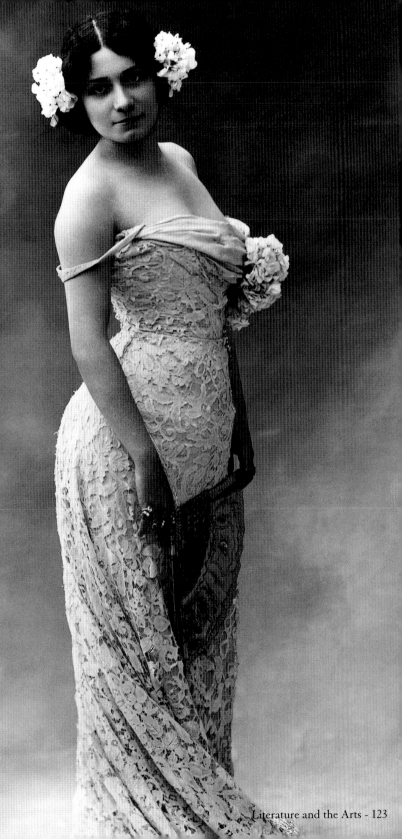

Cora Laparcerie
(1875-1951)

This pretty young actress, at the dinner party Marcel Proust gave on April 25th, 1899, in honor of Robert de Montesquiou, Anatole France and Anna de Noailles, recited a treasury of poems signed by the three writer-poets. She would later marry the playwright Jacques Richepin.

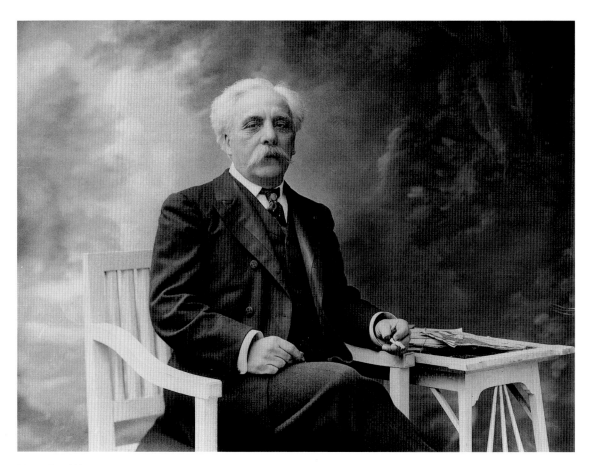

November 29th, 1905

Gabriel Fauré
(1845-1924)

It was probably at the Comte de Saussine's that in 1893 Proust met Gabriel Fauré, whose scores he greatly appreciated: "Sir, I not only love, admire, adore your music, but I was, and still am, in love with it."[73] One of his two sonatas for violin and piano – along with the one in D minor by Camille Saint-Saëns – may have suggested to Proust certain themes of the Vinteuil* sonata, and we know that the melody on Baudelaire's *Chant d'Automne* was the leitmotif of his flirtation with Marie Finaly.

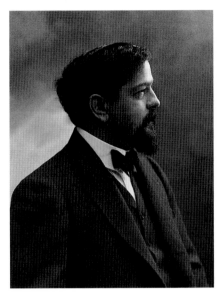

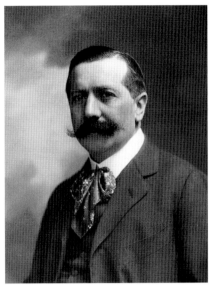

April 3rd, 1909
Claude Debussy
(1862-1918)

Although he was a great admirer of his work, especially after *Pelléas et Mélisande* (1902), Proust was never close to Debussy. While he often saw him in the Daudets' circle at the Café Weber, the strong discrepancy between the musical conceptions of "Claude de France" and those of Reynaldo Hahn, as well as the composer's taciturn, touchy temperament, scarcely encouraged their becoming friends. Several passages of the Vinteuil septet were inspired by *La Mer*, a symphonic poem by Debussy, and by his string quartet.

1911
Édouard Risler
(1873-1929)

The pianist Édouard Risler accompanied the selection of Proust's poems, *Portraits de peintres*, which were recited at Madeleine Lemaire's and set to music by Reynaldo Hahn, in 1895. Proust, who had deep regard for the pianist, asked him, on the occasion of the dinner party he gave at the Ritz in 1907, to come and play to substitute Gabriel Fauré, who was ill. Risler played Couperin, Chopin, Fauré and, at Proust's request, the overture to Richard Wagner's *Die Meistersinger* and the "Death of Isolde" from *Tristan und Isolde*.

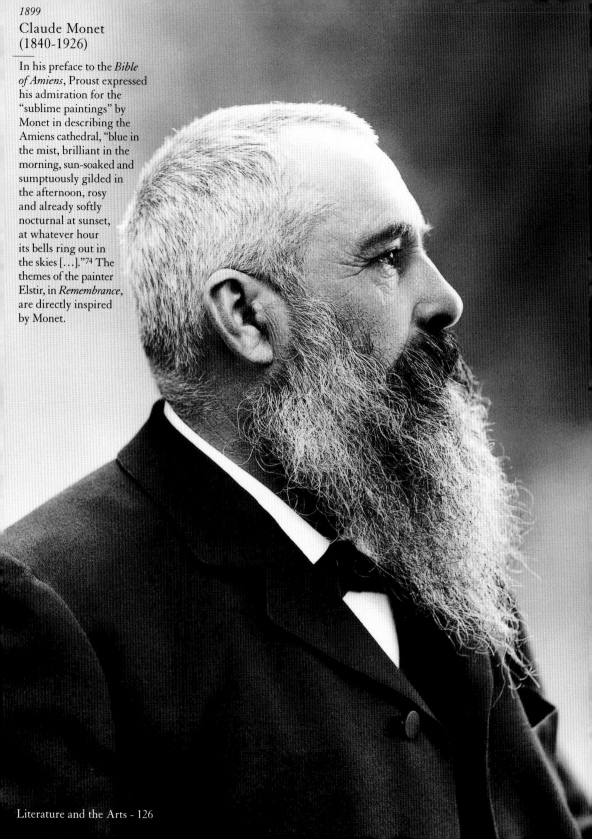

Claude Monet
(1840-1926)

In his preface to the *Bible of Amiens*, Proust expressed his admiration for the "sublime paintings" by Monet in describing the Amiens cathedral, "blue in the mist, brilliant in the morning, sun-soaked and sumptuously gilded in the afternoon, rosy and already softly nocturnal at sunset, at whatever hour its bells ring out in the skies [...]."[74] The themes of the painter Elstir, in *Remembrance*, are directly inspired by Monet.

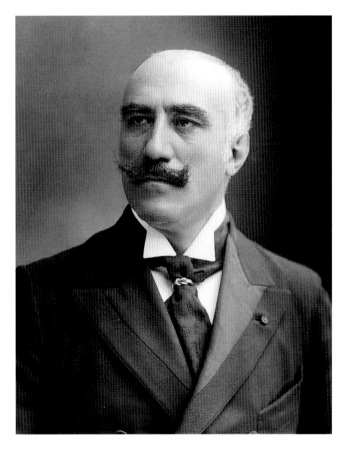

circa 1885

Jean Béraud
(1849-1936)

A genre painter, Jean Béraud became known for his scenes of
society life – at the club, the Opéra, the Bois – scenes that probably
supplied some of Elstir's favorite subjects. He was a frequent
visitor in Madeleine Lemaire's salon and also belonged to the
circle of the Comtesse Potocka, who gathered numerous artists in
her salon on the avenue de Friedland. Proust asked him to be his
witness on the occasion of his duel with Jean Lorrain, in the
woods of Meudon, February 6th, 1897. He was among the brilliant
society invited to the dinner party that Proust gave on July 1st,
1907, for Gaston Calmette in a private dining room at the Ritz.

1930

Léon Daudet
(1867-1942)

Essayist, novelist, literary and art critic, Léon Daudet was one of
the founders of the Royalist newspaper *L'Action française*. Brilliant
and witty, he entertained the circle that gathered at the Café
Weber with his imitations of Zola or of Caran d'Ache. That is
where he met Proust, whom he knew from having seen him at his
parents'. "Around seven-thirty a pale young man with doe-like
eyes would arrive at Weber's, nibbling on or fidgeting with
his drooping brown moustache, wrapped up in woolens like a
Chinese bibelot. [...] Pretty soon his lips would let fall,
pronounced in a hesitant, hard-pressed tone, exceptionally
refreshing remarks and diabolically accurate perceptions. [...]
It was Marcel Proust."[75] Daudet wielded all his influence so
the Goncourt jury, of which he was a member, would award
the prize to *Within a Budding Grove*, on December 10th, 1919.

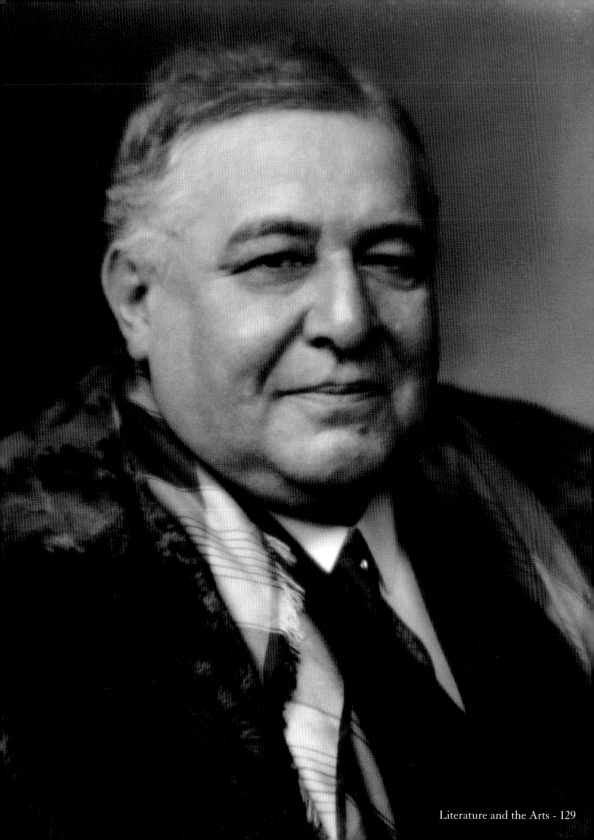

1932

Federico de Madrazo
(1878-1938)

Federico de Madrazo, nicknamed Coco, especially known for
his talent as a painter, was also a singer, composer and writer.
His father's second wife was Maria Hahn, Reynaldo's sister.
He was a devoted friend of Proust, who gratefully remembered
the way he had talked to him about painting during their trip
to Venice with Reynaldo in 1900. The sculptor Ski*, a habitué
of Mme. Verdurin's receptions, owed a great deal to this
model – *"such an artistic temperament,"* as Madeleine Lemaire
used to say.

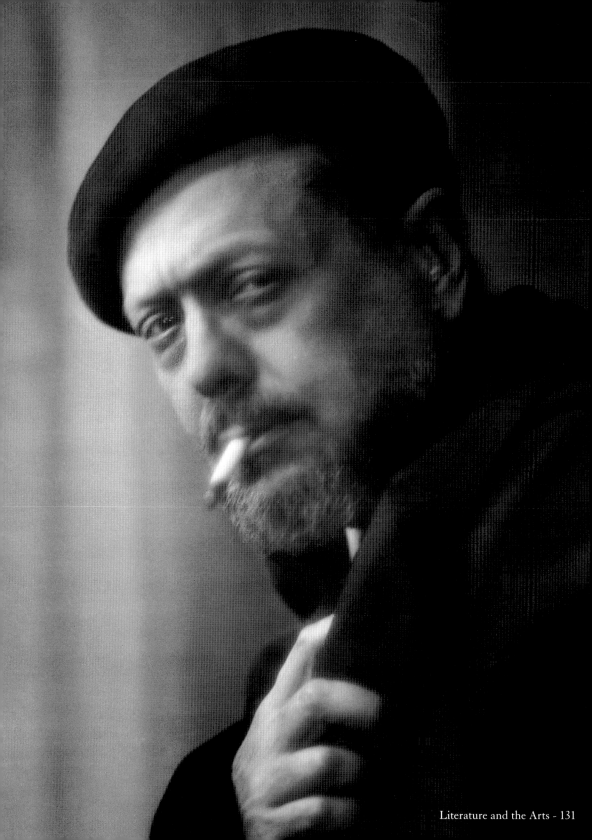

1930

Jean Cocteau
(1889-1963)

Cocteau's life crossed Proust's on several occasions. "I owe many precious things to Léon Daudet […], it is thanks to him that I met the Empress Eugénie, Jules Lemaître and Marcel Proust," the poet wrote in his *Portraits-souvenir* (chap. XIV). In 1911 Reynaldo Hahn composed music for a ballet on one of his scenarios, *Dieu bleu*, at Diaghilev's request. "Surprise me!" the latter had challenged Cocteau. On the evening when, at Larue's, in the midst of the troupe of the Ballets Russes, the poet, like Saint-Loup, leapt on the table, Proust was there and, in a few easy rhymes, described the scene: "Like a sylph to the ceiling, or on snow a thin ski / Jean leaped on the table and dropped by Nijinsky."[76]

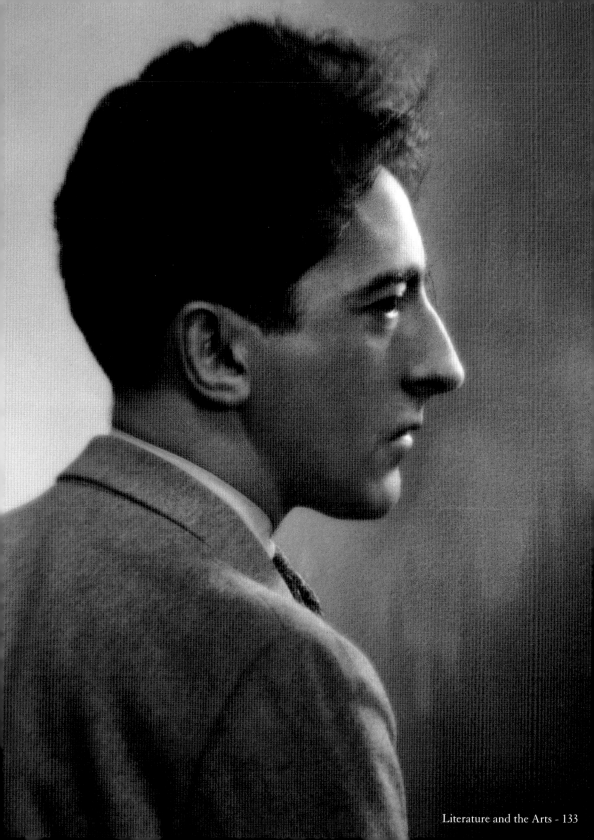

At the beginning *of Remembrance*, the ball at the Princesse de Léon's is mentioned three times. The most magnificent costumes ordered from the famous couturiers or the wardrobe-master of the Opéra bedecked the guests of that fête, some of whom had their photograph taken at the Nadar studio. For hosts and hostesses, the performances – musical, literary or theatrical – that animated their parties were an elegant way to entertain their guests, the most talented of whom were invited to take part in these drawing room events, alongside the most seasoned performers. Thus at Madeleine Lemaire's, or again at Lydie Aubernon's, in her "Messine theater," and then rue Monchanin, where Réjane and Antoine did not hesitate to put on *La Parisienne* by Henri Becque with the hostess's friends.

A large enough space had to be planned for the actors' performance and, when feasible, the house design featured a stage and a theater, as we can see below in Louis Stern's *hôtel particulier* in Paris.

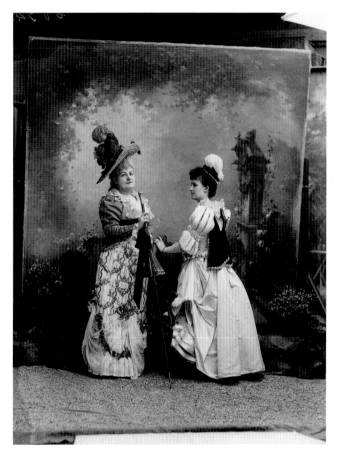

June 18th, 1891
The Princesse de Léon, née Herminie de Verteillac, and her daughter.

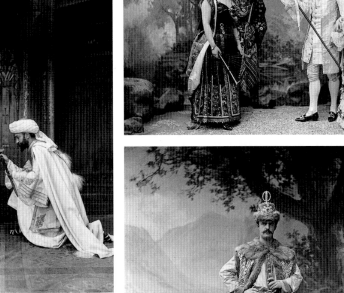

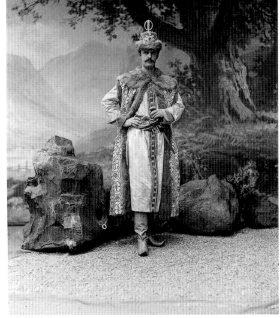

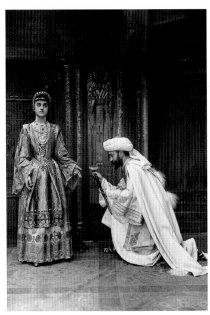

Above, Mlle. de Luynes and the Marquis
de Chasseloup (*May 29ᵗʰ, 1891*); top
right, the Prince and Princesse Radziwill,
the Duc and Duchesse de Luynes
(*May 29ᵗʰ, 1891*); right, the Duc d'Uzès
in the costume of a Moscovite nobleman
(*May 30ᵗʰ, 1891*).

Next page:
Mlle. de Brantes (*May 29ᵗʰ, 1891*).

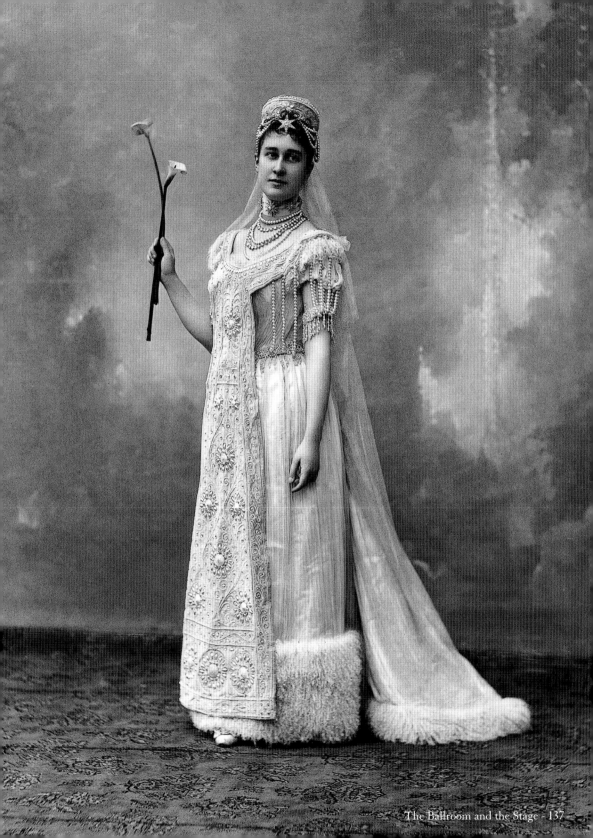

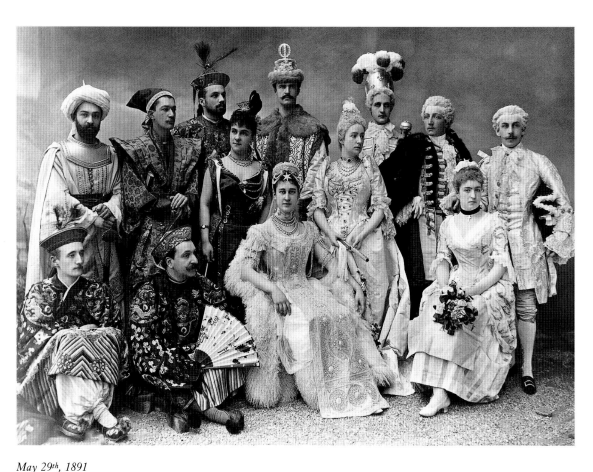

May 29th, 1891

Costume ball of the Princesse de Léon at the Nadar studio

From left to right, standing: the Marquis de Chasseloup, the Comte de Chasseloup, an unidentifed person, the Princesse Dominique Radziwill, the Duc d'Uzès, the Duchesse de Luynes, Louis-Emmanuel d'Uzès, the Marquis Boni de Castellane (as the Maréchal de Saxe), the Duc de Luynes; seated: an unidentified person, the Prince Radziwill, Mlle. de Brantes, Mlle. de Crussol. *Le Gaulois* of May 27th, 1891, devoted half a page to this party, held the night before, that supposedly netted a profit of three million gold francs to Parisian retailers.

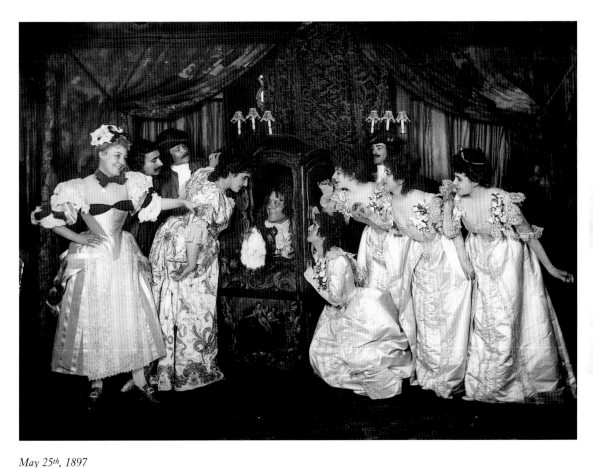

May 25th, 1897

Performance of the light opera *Le roi l'a dit*, by Léo Delibes, at Madeleine Lemaire's

In the foreground, from left to right: Mme. Dettelbach, the Comtesse de Maupeou, Lucien Fugère (of the Opéra-Comique), Mme. Charles Max, Mlle. Jeanne Clément, Mlle. de Soria, Mlle. Suzette Lemaire; in the background: Pierre Lavallée and two unidentified persons.

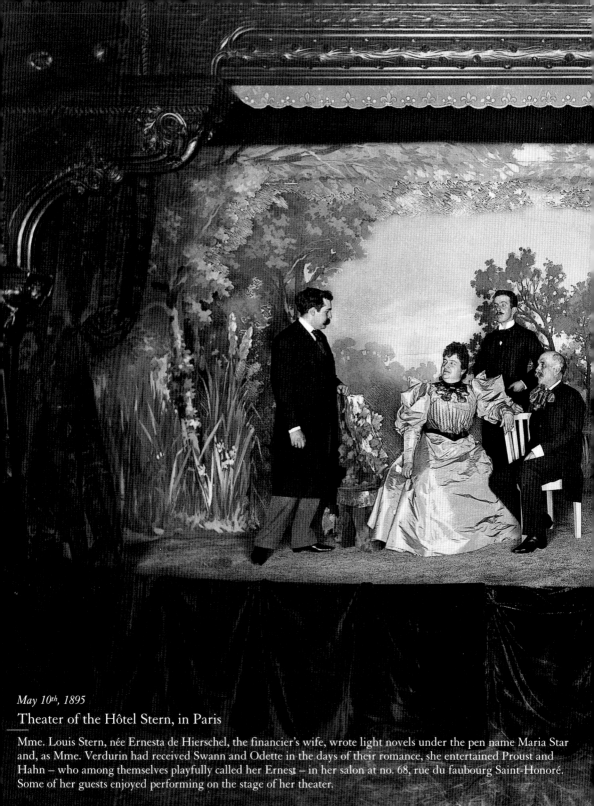

May 10th, 1895

Theater of the Hôtel Stern, in Paris

Mme. Louis Stern, née Ernesta de Hierschel, the financier's wife, wrote light novels under the pen name Maria Star and, as Mme. Verdurin had received Swann and Odette in the days of their romance, she entertained Proust and Hahn – who among themselves playfully called her Ernest – in her salon at no. 68, rue du faubourg Saint-Honoré. Some of her guests enjoyed performing on the stage of her theater.

RESIDENCES

Nadar's remarkable reportage devoted to the Château of Ermenonville and the Parisian *hôtel particulier* of Prince Constantin Radziwill immortalized the interior of one of the great residences of the late nineteenth century. These room-by-room shots (the exact localization is attested by the studio order books) reflect the trends of the day.

At the time, the taste for bric-à-brac was as widespread with the bourgeoisie as with the aristocracy: the pleasure of accumulation and the dread of emptiness. To hold a salon, to give a dinner party or a ball, society entertained its guests in interiors whose opulence reflected the owner's social status. In the formal rooms, eighteenth-century French prevailed – a favorite with those who looked back nostalgically to an idealized Ancien Régime – as well as polychrome neo-Renaissance or somber Louis XIII: "respectable eclectism," "tasteful disorder where ordinary furniture is placed next to precious items, original pieces and copies."[77] Picturesqueness won out in the intimacy of the sitting room and the boudoir, where we notice the influence of Samuel Bing, importer of those curios from Japan that Odette de Crécy selected for her home on the rue La Pérouse, and then promoter of Art Nouveau, with its alluring, soaring curves that could appeal to a fan of Gallé like Robert de Montesquiou.

As for Marcel Proust, as his work evolved, he gradually got rid of the furniture, rugs and paintings he had inherited from his parents. Secluded in his room on the rue Hamelin, entirely devoted to writing *Remembrance*, he recreated a decor out of his own inner world.

1884
A detail of Prince Radziwill's study at Ermenonville, showing Nadar's
photograph of Léon, the Prince's son.

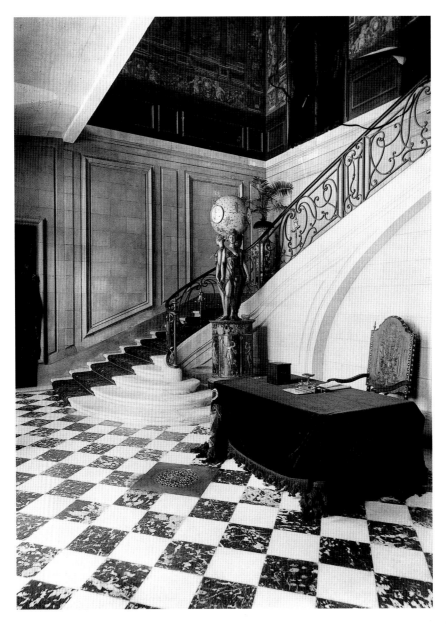

1884

Ermenonville

Entrance hall

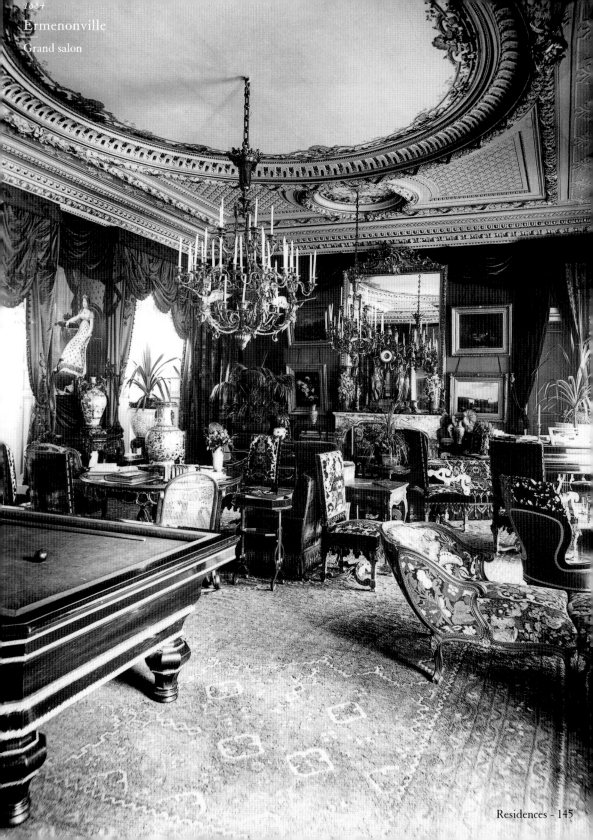

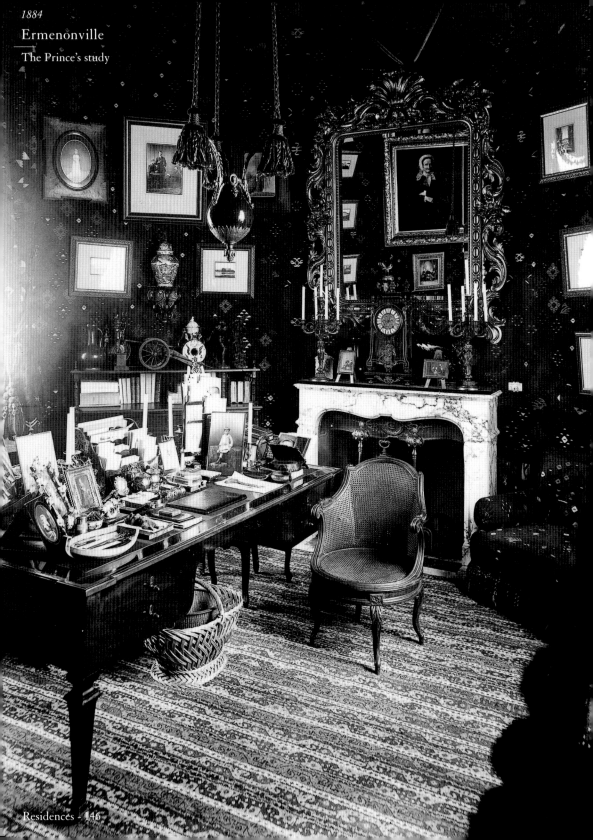

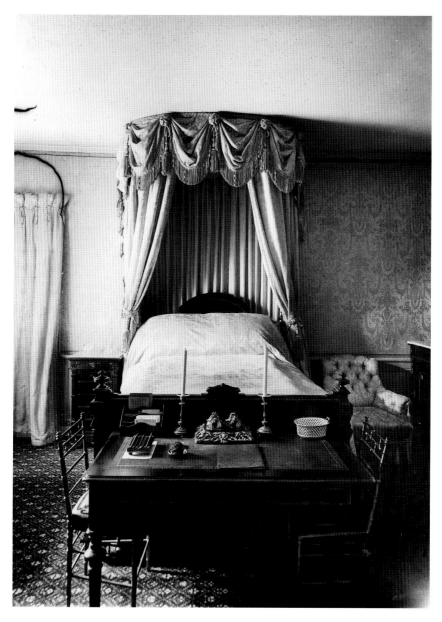

1884

Ermenonville

Guest room

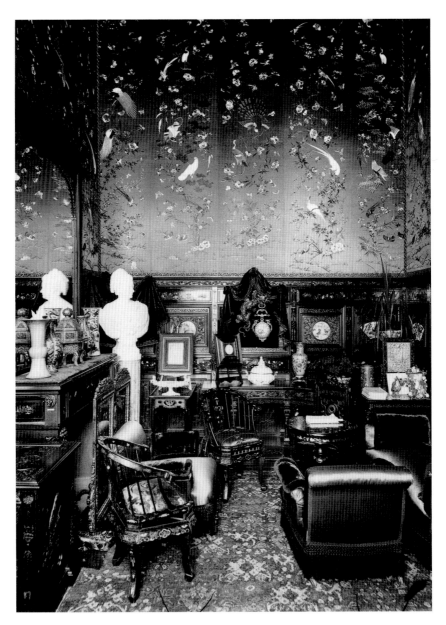

1884

Ermenonville

The Princess's Japanese boudoir

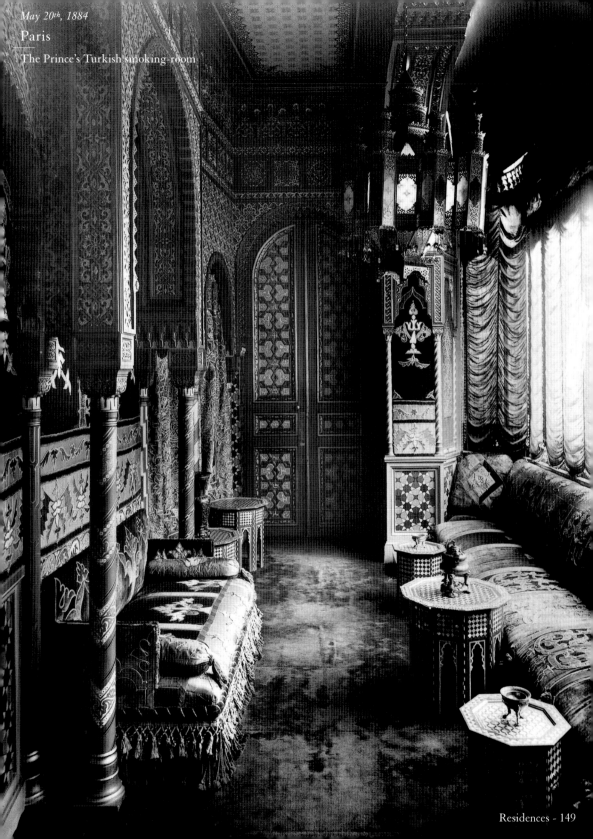

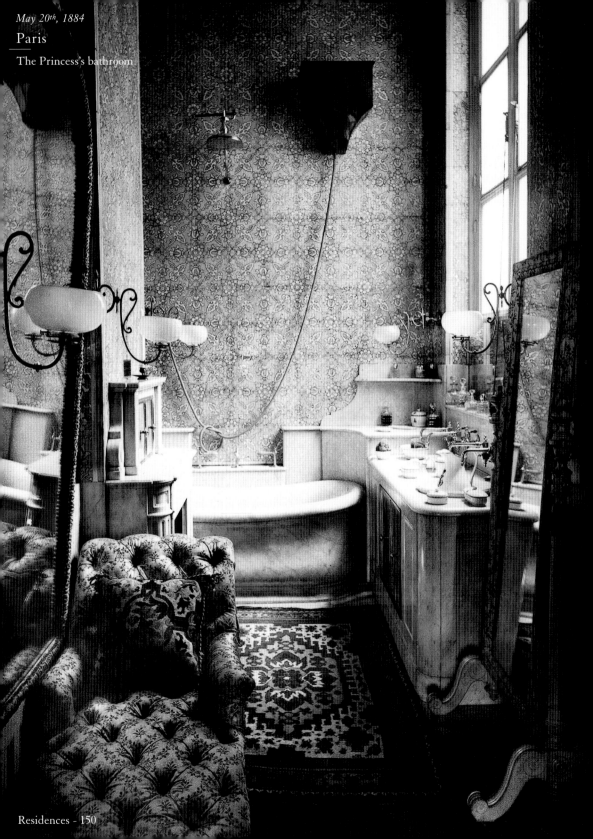

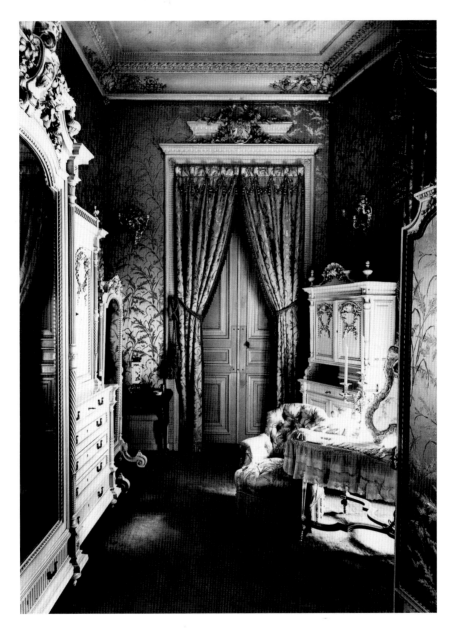

May 20th, 1884

Paris

The Princess's dressing room

DARTAGNAN

May 20th, 1884

Paris

The Prince's stables

1. Kolb, XXI, p. 346.

2. Freund, p. 43.

3. Boyer, pp. 64-65.

4. Quoted in Rouillé, p. 273.

5. Freund, pp. 66-67.

6. *Id.,* p. 67.

7. *Remembrance* 1929, Part VI, *The Captive*, pp. 273-274.

8. Daniel Halévy, quoted in Painter, I, ch. 5, pp. 62-63.

9. *Remembrance* 1952, vol. VII, *Cities of the Plain*, part I, pp. 250-251.

10. Quoted in Painter, II, ch. 8, p. 159.

11. *Remembrance* 1925, vol. II, *The Guermantes' Way,* part IV, p. 44.

12. Kolb, II, p. 52.

13. Letter dated March 24th (Kolb, XI, p. 76)

14. Kolb, XI, p. 19.

15. Kolb, XIV, p. 138.

16. See Painter, II, ch. 2, p. 40.

17. "Portrait du prince Léon Radziwill," *Les Cahiers Marcel Proust*, n. 1, 1927; reprinted in *Contre Sainte-Beuve... Essais et Articles*, pp. 474-477.

18. *Remembrance* 1924, part II, *Within a Budding Grove*, vol. I, p. 106.

19. *Remembrance* 1951, vol. XII, *Time Regained*, p. 414. Simone Arman de Caillavet was to marry the writer André Maurois.

20. Kolb, VII, p. 275.

21. Kolb, III, pp. 349-350.

22. *Remembrance* 1951, vol. XII, *Time Regained*, pp. 271-272.

23. *Remembrance* 1925, part III, *The Guermantes' Way*, vol. I, p. 64 (a description of a toilette of the Duchesse de Guermantes).

24. *Remembrance* 1955, vol. I, *Swann's Way,* Part I, Swann in Love, p. 283.

25. Painter, I, ch. 7, p. 99.

26. Kolb, I, p. 305.

27. Painter, I, ch. 4, p. 46.

28. Letter to Robert de Billy, 1912 (Kolb, XI, p. 128).

29. One of her quips was borrowed in a discarded passage of *Cities of the Plain* (Painter, II, ch. 8, p. 177).

30. *Remembrance* 1924, part II, *Within a Budding Grove,* vol. II, p. 87.

31. See Mondor, p. 767.

32. *Remembrance* 1924, part II, *Within a Budding Grove,* vol. I, p. 106.

33. Read "Roses pour un palais défunt," by Vincent Bouvet, *Monuments Historiques*, n. 108, 1980, pp. 21-26.

34. Quoted in Diesbach, p. 409.

35. *Remembrance* 1925, part IV, *The Guermantes' Way*, vol. II, p. 198.

36. See Painter, II, ch. 15, p. 315.

37. "[Le salon de la comtesse Aimery de La Rochefoucauld]" in *Contre Sainte-Beuve... Essais et Articles*, p. 438.

38. Letter to Robert de Montesquiou, "[July 2? 1893]" (Kolb, I, p. 219).

39. Quoted in Albaret, p. 40.

40. Quoted in Jullian, p. 98.

41. See Painter, II, ch. 7, p. 138.

42. See Cossé Brissac, p. 72.

43. Quoted in Jullian, p. 99.

44. *Remembrance* 1925, part III, *The Guermantes' Way*, vol. I, p. 101.

45. Vento, p. 269.

46. Mugnier, November 8, 1908, pp. 173-174.

47. "Le salon de la comtesse Potocka," signed "Horatio"; reprinted in *Contre Sainte-Beuve... Essais et Articles*, pp. 489-494.

48. Quoted in Vanderpooten, note p. 527. The Comtesse, although Italian, spelled her Christian name with a double m.

49. See Albaret, pp. 279-281.

50. Quoted in Painter, II, ch.1, pp. 12-13.

51. Pougy, pp. 53-54.

52. Kolb, VI, p. 205.

53. Quoted in Painter, II, ch.3, p. 69.

54. Paris, Félix Juven, 1903; *Le Gaulois* of July 1st, 1903, mentions

that the book had been issued the day before; see Kolb, XXI, p. 596.

55. Albaret, p. 430.

56. Letter to Gabriel de Yturri, September 1895 (Kolb, I, p. 426).

57. Daudet, p. 28.

58. From an article by Jean Lorrain in *L'Événement*, November 7th, 1887.

59. *Remembrance* 1925, part III, *The Guermantes' Way*, vol. I, pp. 55-56.

60. Words quoted in *Comœdia*, January 20th, 1920; reprinted in *Contre Sainte-Beuve... Essais et articles*, pp. 600-601.

61. Read "La cour aux lilas et l'atelier des roses. Le salon de Mme. Madeleine Lemaire," *Le Figaro*, May 11th, 1903; reprinted in *Contre Sainte-Beuve... Essais et articles*, pp. 457-464.

62. See Painter, I, ch. 12, pp. 218-219.

63. Cattaui, p. 13.

64. According to Gustave Kahn, *Symbolistes et décadents* (1902), quoted in Mondor, p. 476, note 1.

65. Words of the writer on art Gabriel Mourey, a habitué of the Rue de Rome on Tuesdays, quoted by Mondor (p. 476).

66. Painter, II, ch. 16, p. 327.

67. Letter to Natalie Barney, January 1921 (Kolb, XX, p. 91).

68. Quoted in Painter, I, ch. 16, p. 331.

69. Painter, I, ch. 9, p. 140.

70. See letter to Daniel Halévy, May 22nd, 1888 (Kolb, XXI, p. 552).

71. According to Mme. Daudet, quoted in Painter, I, ch. 11, p. 186.

72. See Painter, I, ch. 7, p. 107.

73. Kolb, II, p. 162.

74. *On Reading Ruskin*, p. 19.

75. Daudet, pp. 503-504.

76. Painter, II, ch. 8, p. 162.

77. Marc Le Cœur, "À la ville et à la campagne. Chez le prince Radziwill en 1884," *Monuments historiques*, n. 195, March 1995, pp. 46-52.

BIOGRAPHICAL DATA

1871
July 10 – Birth of Marcel Proust, son of Adrien Proust and Jeanne Weil, in Paris.

1873
May 24 – Birth of his brother Robert Proust.

1880
First attack of asthma.

1882-1889
Attends the Lycée Condorcet.

1888-1889
Begins to go out in society, salons of Mme. Straus, of Mme. Lemaire.

1889
Military service at Orleans.

1892
August – Admitted to the École des Sciences Politiques. Literary debut in *Le Banquet*.

1893
Meets Robert de Montesquiou at Madeleine Lemaire's. October 3 – Death of his friend Willie Heath. Law degree.

1894
Meets Reynaldo Hahn. Dreyfus is arrested.

1895
Literature degree. Assistant at the Mazarine Library, he asks for a year's leave. Stay in Brittany with Reynaldo Hahn. Begins *Jean Santeuil*. Death of his maternal grandmother.

1896
Publication of his first book, *Pleasures and Regrets*, by Calmann-Lévy.

1897
Duel with Jean Lorrain.

1898
Gathering of signatures in defense of Dreyfus. Attends the Zola trial.

1899
Begins to translate Ruskin, with the help of Marie Nordlinger. June – Dreyfus is set free.

1900
Trips to Venice.

1902
Visits several cathedrals with the Bibesco brothers and their friends.

1903
February 2 – Wedding of Robert Proust. November 26 – Death of Professor Adrien Proust.

1904
Publication, by the Mercure de France, of his translation of *The Bible of Amiens*, by John Ruskin, with a preface and notes.

1905
September 25 – Death of Mme. Proust.

1905-1912
Writes a large part of *Remembrance of Things Past*.

1907
Summer at Cabourg (he will spend every summer there until 1914); automobile trip through Normandy with Agostinelli.

1909
Works on a study on Sainte-Beuve. Reads to Reynaldo Hahn the beginning of *Swann's Way*.

1912
Le Figaro publishes excerpts from *Remembrance of Things Past*. He employs Agostinelli as his secretary.

1913
Has *Swann's Way* published at his own expense, by Grasset. Céleste Albaret enters his service.

1914
May 30 – Death of Agostinelli.

1919
December 10 – He is awarded the Prix Goncourt for *Within a Budding Grove*.

1920
Appointed chevalier of the Légion d'Honneur. Publication of *The Guermantes' Way*, vol. I.

1921
Publication of *The Guermantes' Way*, vol. II, and of *Cities of the Plain*, vol. I. Visit to an exhibition of the Dutch masters at the Jeu de Paume museum, where he has a serious malaise.

1922
Publication of *Cities of the Plain*, vol. II. November 18 – Death of Marcel Proust.

Posthumous publications

1923
The Captive, volumes I and II.

1925
Albertine Lost.

1927
Time Regained, volumes I and II. *Chroniques.*

1930
General correspondence.

1952
Jean Santeuil.

1954
Against Sainte-Beuve.

BIBLIOGRAPHY

Works by MARCEL PROUST

Remembrance of Things Past, translated by C.K. Scott Moncrieff, Chatto and Windus, London: *Within a Budding Grove* 1924, *The Guermantes' Way* 1925, *Cities of the Plain* 1952, *Swann's Way* 1955.

Remembrance of Things Past, Part Six, *The Captive*, Alfred Knopf, New York 1929.

Remembrance of Things Past, Time Regained, translated by Stephen Hudson, Chatto and Windus, London 1951.

On Reading Ruskin, Prefaces to *La Bible d'Amiens* and *Sésame et les Lys*, with selections from the Notes to the Translated Texts. Translated and edited by Jean Autret, William Burford and Philip J. Wolfe, with an introduction by Richard Macksey, Yale University Press, New Haven and London 1987.

Contre Sainte-Beuve, preceded by *Pastiches et mélanges* and followed by *Essais et articles,* Paris, Gallimard, "Bibliothèque de la Pléiade," (1971), 1984.

Écrits de jeunesse, texts assembled, présenté and annotated by Anne Borrel, Paris, Institut Marcel-Proust International, 1991.

Correspondence

Lettres à Reynaldo Hahn, presented, dated and annotated by Philip Kolb, preface by Emmanuel Berl, Paris, Gallimard, 1956; 2nd edition, revised, 1984.

Choix de lettres, presented, dated and annotated by Philip Kolb, Paris, Plon, 1965.

Lettres retrouvées, presented, dated and annotated by Philip Kolb, Paris, Plon, 1966.

Correspondance de Marcel Proust, text established, presented, dated and annotated by Philip Kolb, Paris, Plon, 1976-1993, 21 vol. edition abbreviated here in Kolb.

"Marcel Proust et la musique d'après sa correspondance," by Denise Mayer, *La Revue musicale*, 1979.

Mon cher petit, lettres à Lucien Daudet (1895-1897, 1904, 1907, 1908), edition established, prefaced and annotated by Michel Bonduelle, Paris, Gallimard, 1991.

BIOGRAPHIES AND MEMORABILIA

Albaret (Céleste), *Monsieur Proust,* Paris, Laffont, 1979.

Boyer (Véronique), *L'Image du corps dans "À la recherche du temps perdu,"* preface de Daniel Oster, Paris, publisher unknown, 1984.

Breteuil (Marquis de), *La Haute Société, journal secret, 1886-1889,* Paris, Atelier Marcel Jullian, 1979.

Cattaui (Georges), *Proust perdu et retrouvé,* Paris, Plon, series "La recherche de l'absolu," 1963.

"Centenaire de Marcel Proust," *Europe,* August-September 1970.

Clarac (Pierre) and Ferré (André), *Album Proust,* Paris, Gallimard, "Bibliothèque de la Pléiade," 1965.

Cocteau (Jean), *Portraits-souvenir 1900-1914,* Paris, Grasset, 1935.

Cossé Brissac (Anne de), *La Comtesse Greffulhe,* Paris, Perrin, series "Terres des femmes," 1991.

Daudet (Léon), *Souvenirs et polémiques*, Paris, Laffont, series "Bouquins," 1992.

Diesbach (Ghislain de), *Marcel Proust,* Paris, Perrin, 1991.

Duchêne (Roger), *L'Impossible Marcel Proust,* Paris, Laffont, 1994.

Erman (Michel), *Marcel Proust*, Paris, Fayard, 1994.

Francis (Claude) and Gontier (Fernande), *Marcel Proust et les siens,* followed by the recollections of Suzy Mante-Proust, Paris, Plon, 1981.

Freund (Gisèle), *Photographie et société*, Paris, Seuil, series "Points," section "Histoire," 1974.

Gramont (Élisabeth de), *Souvenirs du monde de 1890 à 1940*, Paris, Grasset, 1966.

Id., *Marcel Proust*, Paris, Christian de Bartillat, 1991.

Jullian (Philippe), *Robert de Montesquiou, un prince 1900,* Paris, Perrin, 1965.

Mauriac (Claude), *Proust par lui-même*, Paris, Seuil, series "Écrivains de toujours," 1953.

Maurois (André), *À la recherche de Marcel Proust*, Paris, Hachette, 1949.

Mondor (Henri), *Vie de Mallarmé*, Paris, Gallimard, (1941), 1943.

Mugnier (abbé), *Journal, Paris,* Mercure de France, series "Le temps retrouvé," 1985.

Painter (George D.), *Marcel Proust, A Biography*, Chatto and Windus, London 1959 (vol I), 1965 (vol. II).

Pougy (Liane de), *Mes cahiers bleus*, Paris, Plon, 1977.

Pozzi (Catherine), *Journal (1913-1934)*, preface by Laurence Joseph, Paris, Ramsay, series "Pour mémoire," 1987.

Prinet (Jean) and Dilasser (Antoinette), *Nadar*, Paris, Armand Colin, 1966.

Rouillé (André), *La Photographie en France, textes et controverses: une anthologie, 1816-1871*, Paris, Macula, 1989.

Tadié (Jean-Yves), *Proust et le roman*, Paris, Gallimard, series "Tel," 1971.

Id., *Marcel Proust*, Paris, Gallimard, series "Biographies," 1996.

Vanderpooten (Claude), *Samuel Pozzi, chirurgien et ami des femmes*, Paris, In fine-V et O, series "Histoire," 1992.

Vento (Claude) [Violette], *Les Grandes Dames d'aujourd'hui*, with ill. by Saint-Elme Gautier, Paris, Dentu, 1886.

For further bibliographical information contact the Société des Amis de Marcel Proust et d'Illiers-Combray, 28120 Illiers-Combray.

✦ Serial number of the reproduced print; the capital letter following the number indicates the format of the glass plate: B = 30 x 40; G = 21 x 27; N = 18 x 24; P = 13 x 18; R = 15 x 21. W = stereoscopic view; and the lower case letters: t for the top, b for the bottom, r for the right and l for the left pose visible on the same glass plate.

INDEX